WYNDHAM LEWIS

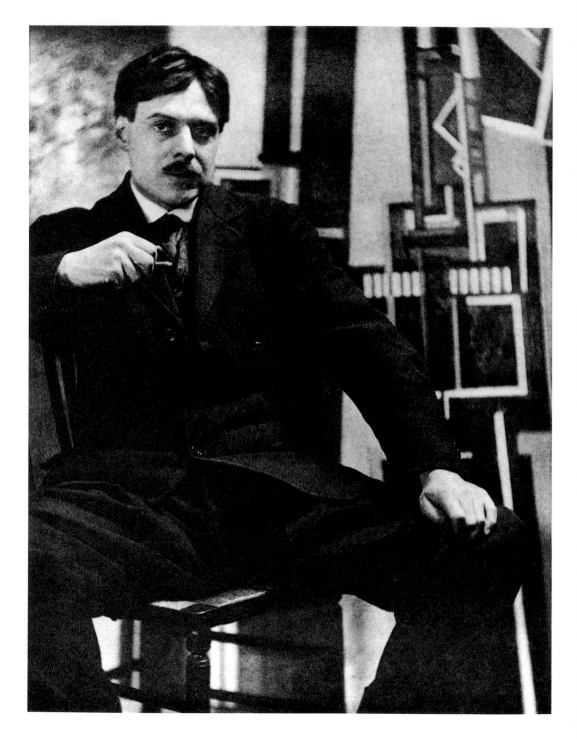

WYNDHAM LEWIS

Richard Humphreys

British Artists

Tate Publishing

Acknowledgements

My first real contact with Wyndham Lewis took place exactly thirty years ago in Cambridge. J.H. Prynne's lecture on 'Enemy of the Stars', Walter Michel's recently published catalogue of the paintings and drawings, Richard Cork's Vorticism exhibition at the Hayward Gallery and Alan Munton's enthusiasm, set me off on an interest which finds some kind of conclusion with this short introduction. Since then I have benefited from the passion and knowledge of many others – Cy Fox, Michael Durman, Paul O'Keeffe, Peter Caracciolo and Graham Lane have been particularly important in sustaining my engagement with this amazing and tricky character. Andrew Brighton and Lisa Tickner have provided me with invaluable insights. Above all, I am indebted to the work of Paul Edwards whose recent magisterial study of Lewis made my job of trying to condense a lot into a short space so much easier. As ever I must thank my daughter Olivia, my mother and my parents-in-law, Pamela and Daniel Waley, for their endless support of all I do.

General Editor: Richard Humphreys
Curator, Programme Research, Tate

First published 2004 by order of
the Tate Trustees
by Tate Publishing, a division of
Tate Enterprises Ltd,
Millbank, London SW1P 4RG
www.tate.org.uk

© Tate 2004

British Library Cataloguing in Publication Data
A catalogue record for this book is available from the British Library

ISBN 1 85437 524 5

Distributed in North America by Harry N. Abrams, Inc., New York
Library of Congress Control Number: 2004102571
Concept design James Shurmer
Book design Caroline Johnston
Printed in Hong Kong by South Sea International Press Ltd
Front cover: *Composition* 1913 (fig.13, detail)
Back cover: *Edith Sitwell* 1923–36 (fig.29, detail)
Frontispiece: Wyndham Lewis sitting in front of a lost canvas, 25 February 1916
National Portrait Gallery, London
Measurements of artworks are given in centimetres, height before width, followed by inches in brackets

CONTENTS

1

'A SKELETON IN THE CUPBOARD'

After breakfast, for instance (a little raw meat, a couple of blood-oranges, a stick of ginger, and a shot of Vodka – to make one see Red) I make a habit of springing up from the breakfast-table and going over in a rush to the telephone book. This I open quite at chance, and ring up the first number upon which my eye has lighted. When I am put through, I violently abuse for five minutes the man, or woman of course (there is no romantic nonsense about the sex of people with an Enemy worth his salt), who answers the call. This gets you into the proper mood for the day.[1]

Wyndham Lewis is the most controversial figure in twentieth-century British art. Simultaneously admired and vilified, his art, writing and public personae have ensured that he remains as awkward a presence in today's historical imagination as he was for his peers during his lifetime. A friend, and enemy, of major figures such as T.S. Eliot, Walter Sickert, Virginia Woolf, Augustus John, James Joyce and Ezra Pound, Lewis lived a heroically complex life with an energy and passion which is at least impressive in its scale and ambition. More importantly, this life produced a body of work in art and writing which has few rivals in its originality, power and scope.

There has been no shortage of admirers of Lewis, from W.B. Yeats, who at one point said he was Lewis's 'greatest disciple', and Henry Moore, who described him as 'our only great man', in his lifetime, to Saul Bellow and David Bowie in recent years. His life was, and his work remains, resolutely 'modern', even 'post-modern', and thus are still an inspiration to many in Anglo-American and European culture today. His Socratic play with self and style, invention of alternative realities, Manichean vision, critique of consensual perceptions and the 'society of the spectacle' and other prophetic insights, make him an exciting and unsettling discovery for the unsuspecting initiate. For an English audience, in particular, his analyses of *The Mysterious Mr Bull* (the title of a book published in 1938) and of national identity and culture remain acute and invigorating.

This claim for Lewis's contemporary significance seems, however, to contradict an opposing status as a self-marginalised and paranoid figure, consumed with a misanthropic resentment which expressed itself not only in often libellous satire of his contemporaries, but also in a passing but undeniable sympathy for fascism, a callous contempt for generous friends, an apparent distaste for 'others' and a host of other disagreeable characteristics – Ernest Hemingway was just one acquaintance who found Lewis 'got under his skin', belatedly claiming that he had the eyes of 'an unsuccessful rapist'. His

culpability in many of these matters is hotly debated, not least because of his wilful inconsistency in behaviour and in expressing his views, and because one man's, or woman's, vice can be someone else's virtue or sceptical mischief. It is up to the individual readers to decide where they stand on these issues and how seriously or not to take 'The Enemy's' frequently deliberate aggressive provocations. Lewis sought an unusually close, if curious, relationship with his public as he tried to defend an elite notion of art in an age of mass culture. As he told the *Daily Herald* journalist who visited him in his studio off Tottenham Court Road in 1932, as an 'Enemy' he was 'much the same as a Friend – a very *intimate* friend, who has forgotten why or how he ever came to begin the relationship'.[2] The menacing, toothy grin is almost palpable many decades later.

This short account of Lewis's visual art will necessarily draw on his writings as a novelist, literary critic and poet and as an often first-rate, if idiosyncratic, political, cultural and philosophical commentator. In total he wrote over forty books and hundreds of essays and articles. Although Lewis consciously tried to keep his writing and art apart – for example, he rarely sought to emulate William Blake, whom he greatly admired, by interweaving them – neither activity can be understood without reference to the other. Lewis slowly and often painfully evolved an imaginative and ultimately humane vision, embracing most areas of human thought and experience, which is the ground for all his creative output. His writings, of course, give the fullest representation of this evolution, while his art embodies it more obliquely, casting, however, brilliant and unexpected shafts of light on the progress of a remarkable and disturbing mind. Above all, this book will demonstrate that Lewis, a superb draughtsman, a subtle painter in oil and watercolour, a truly inventive master of design and a penetrating art critic, is one of the major figures of twentieth-century British art. Lewis was at pains throughout his life to make stout defence of his work and to decry it being denied a central place in the history of modernism, believing himself to have assumed 'a little the position of a skeleton in the cupboard – a cupboard, needless to say, that had to remain locked'.[3] This sense of Lewis both protesting too much and yet speaking the truth is typical of the man, and also reminds one of the quip that 'just because you're paranoid, doesn't mean they aren't out to get you!' Or, perhaps, in Lewis's case, that should be 'out to *forget* you', as has certainly been true in some quarters.

'CRYPTIC IMMATURITY' 1882–1908

How calm those days were before the epoch of wars and social
revolutions when you used to sit on one side of your worktable and I
on the other, and we would talk – with trees and creepers of the
placid Hampstead domesticity beyond the windows, and you used to
grunt with a philosophic despondency I greatly enjoyed. It was the
last days of the Victorian world of artificial peacefulness ... As at that
time I had never even heard of anything else, it seemed to my young
mind in the order of nature. You – I suppose – knew it was all the
stunt of an illusionist. You taught me many things.
But you never taught me that.[1]

Lewis, himself an arch illusionist, played with his origins and identity almost
as an article of faith. Even his date of birth and age were for many years a mat-
ter of controversy. He insisted for a long time that he was born in 1884 – it was
actually in 1882 – and at one point told friends, according to Osbert Sitwell,
'I'm thirty seven till I pass the word round!'[2] He claimed to have been born in
a yacht during a November storm in the Bay of Fundy – the actual site was
probably on dry land at Amherst, further down the Nova Scotia coast – and
changed his name to Wyndham Lewis by deleting his given name, Percy. This
left it uncertain as to whether he now had a Christian name at all. Through-
out his life, and in his art, Lewis sought to evade easy definition, keeping his
marriage in 1930 a secret from many, for instance, constantly changing his
address and having post sent to a Safety Deposit number. Strangely, this
behaviour was that of a man who sought individual wholeness and responsi-
bility in an age he believed made such aspirations almost impossible.

'Dangerous'

The son of a talented but philandering American father and a patient, artistic
English mother who separated from one another when he was eleven, Lewis
was an only child who was sent to English preparatory schools and then to
Rugby School as a teenager. There he had a mediocre academic career,
excelling only at art, a talent which found few admirers:

> I remember a very big boy opening the door of the study, putting his
> big red astonished face inside, gazing at me for a while (digesting what
> he saw – the palette on my thumb, the brush loaded with pigment in
> the act of dabbing) and then, laconic and contemptuous, remarking
> 'You Frightful Artist!' closed the study door – and I could hear his big
> slouching lazy steps going away down the passage to find some more
> normal company.[3]

This was one of Lewis's first encounters with 'John Bull', the philistine Englishman he both loathed and yet, particularly in his non-public school manifestations, came to rather like, and whom he later tried, with the best of intentions, to 'kill with art'.

The reminiscence also establishes his acute sense of difference while revealing a satirical eye for the body's movements and a strong comic detachment from the events of the world. His later view that a sense of the absurd is at the heart of all philosophy made laughter for him a central human response. These traits were among those which, along with an evident artistic talent, he took with him to the Slade School of Art in January 1899 after Rugby had finally decided he would be better off elsewhere. This was also the year Lytton Strachey and other figures in the future 'Bloomsbury Group' Lewis was to become best enemies with, first met at Cambridge and developed their ideas under the aegis of the philosopher of analytical 'common sense' G.E. Moore.

Lewis was only sixteen at the time and thus a young student who found himself with older men such as the future Camden Town Group painters Spencer Gore and Harold Gilman. His senior teachers were the disciplinarian Professor Fred Brown, the Impressionist painter Philip Wilson Steer and the artist-surgeon Henry Tonks, the Slade's chief drawing master for whom copy-

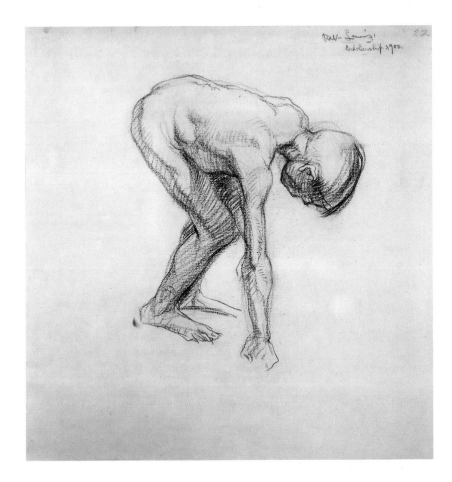

1 *Nude Boy Bending Over* 1900
Black chalk
34.5 × 29
(13½ × 11½)
UCL Art Collections,
University College,
London

ing from classical art was the foundation of fine art. Eventually leaving the clutter of sculptures and casts, the drawing 'donkeys' and scattered pieces of bread used for erasing in the Antique class, Lewis first caught sight of the Slade's 'star', the brilliant, unorthodox teacher of life drawing, Augustus John, in the 'Life Room'. John taught him the art of the currently fashionable Rembrandtesque style, as opposed to that of Michelangelo as Tonks would have wished, and later, as a close friend, encouraged him in his bohemianism and womanising. Lewis's abilities as a draughtsman got him a scholarship in 1900, which alleviated some of the financial pressure on his impecunious mother, and he became a devotee of the drawing of Luca Signorelli, a contemporary of Michelangelo.

A particularly important site for Lewis's development was down Gower Street from the Slade and to the left along Great Russell Street – the British Museum. Here he could not only study the Old Masters, as instructed, but on his way to the Students' Room of the Prints and Drawings department could also look at a multitude of non-Western art: Oriental, American Indian, Oceanic and African artefacts among the many he became familiar with. Furthermore, Lewis became a protégé of a group of older men associated with the museum who held an informal salon at the Vienna Café in New Oxford Street: Laurence Binyon, poet and Assistant Keeper of Prints and Drawings, the books expert R.A. Streatfield, who introduced Lewis to the writings of Samuel Butler, and the extraordinary architect, occultist writer and freemason William Stirling, who ritually committed suicide during the period he was evidently seeking to seduce Lewis. Perhaps most importantly, Lewis met the artist and writer Thomas Sturge Moore, brother of the 'Bloomsbury philosopher' already mentioned, and a close friend of W.B. Yeats, who gave him an intellectual and literary education he would otherwise not have received. Moore's complex ideas about art as a form of devotion in a secular society are clearly present throughout Lewis's writings and the two men remained in touch until Moore's death in 1944.

Lewis's lifestyle and disregard for the rules and regulations of the Slade eventually meant he was expelled in 1901 at the age of nineteen – for poor attendance and for smoking in a corridor in full view of his professor, Fred Brown. His behaviour was considered such a threat by the School that Spencer Gore wrote to a friend in 1902: 'So bitterly do the authorities of the Slade dislike Lewis that anyone going in for a prize or Scholarship is apparently first questioned and his former life examined to find out "whether he is a friend of Lewis". Seems to me that this is nearly as good for him as being great friends with them, as they must have a very high opinion of him to consider him dangerous.'[4]

Doted on by his mother, abhorred by his professors and admired by an influential group of writers, artists and scholars, Lewis must have seemed to himself and others like a great hope for British highbrow culture at the turn of the century. He was in many respects a child of the 'Nineties' – influenced by Symbolist and Decadent art, literature and ideas, and a successor to the great Whistler in his devotion to the 'gentle art of making enemies' and his grand sense of aesthetic mission. Devoted to the 'cult of art', Lewis nevertheless

departed from this culture in wishing to escape the anachronism Sturge Moore's friend the aesthete Charles Ricketts said he felt himself to represent in the modern world. Frustratingly there is little surviving evidence of his art from these early years, aside from a few impressive academic drawings (fig.1) and other works on paper. What we have instead is a fair amount of information about his life as he moved into the often absurd and squalid world of bohemia and began to invent 'Wyndham Lewis'.

'A Good European'

Much of this self-invention took place in the first decade of the twentieth century in continental Europe, away from the intellectual influence of Cambridge and in the melting-pot of an alien bohemia where Nietzsche and Schopenhauer rather than David Hume and G.E. Moore were the presiding spirits. Lewis was never parochial and found British insularity, whether in sophisticated francophile Bloomsbury or in philistine Middle England, one of the nation's abiding and most infuriating flaws. He saw himself at least as 'a good European' and ideally as a 'citizen of the world'.

In 1903 we find him living in a studio in Madrid, sending his mother detailed accounts of his expenses and romantic encounters, drawing from life and visiting the Prado where he was inspired by the Goyas; in 1904 he was in Haarlem, studying Frans Hals and evading the marital manoeuvrings of a landlady and her daughter, and then in rue Delambre, Paris, drawing caricatures for the press and seeking a mistress. This was the year Picasso settled in the 'art capital of the world' and it is possible that Lewis met the Spanish painter – and certainly he met others associated with the Parisian avant-garde – over the next few years. He writes to his mother, who would often join him for periods of his travels, that he is attending talks by Anatole France, courting the poet Mina Loy, supporting the release of Maxim Gorky and going to Russian dances. Like many contemporaries he was fascinated by Russian culture and his writings show his admiration for Dostoevsky, Turgenev and others. It was at this time too that Lewis also began to study philosophy seriously, attending the popular lectures of Henri Bergson at the Collège de France and starting to develop his own complex world view. Bergson was both a great influence on the young Lewis and, later, a target of some of his strongest criticism as he attacked the 'Vitalist' and naturalistic philosophies he believed produced war as well as inferior art.

In 1905 Lewis had acquired the desired mistress, an older German art student called Ida Vendel, and travelled with her to the seaside resort of Noordwijk aan Zee in Holland, to Hamburg and to Paris. Their relationship was a predictable disaster and ended up in what Lewis described as a 'moral cul-de-sac'.[5] Lewis was now fluent in French, competent in Spanish and some Dutch and determined to extend his experience and language skills. In 1906 he continued his artistic education by moving to Munich and studying at Heymann's Academy, before returning to Paris where, he informed John, he was writing prodigious amounts of Baudelairean poetry. Lewis's self-education at this time seems particularly literary and philosophical, an impression reinforced

11

by the virtual absence of any surviving painting and drawing and the respect in which his artistic mentor Augustus John held his reading recommendations. In turn, Lewis, as he told his mother, was so in awe of John's talents that he felt inhibited in his own visual work – and he could certainly never compete sexually with the teasing older man and his 'caravan' of mistresses and numerous children.

One of Lewis's most significant journeys took him to Brittany in 1908, in the company of his mother and the painter Henry Lamb. The region had of course been a favourite haunt of artists, most famously Paul Gauguin, with its wild landscape and 'primitive' inhabitants. Lewis became fascinated by the peasant life he witnessed there and his experiences in places such as Quimperlé and Le Faouët, following the Baedeker as well as his mother's advice, provided material for his first highly unorthodox published writings.

Above all, Lewis was struck by the individual and group psychology of the life he encountered in Brittany and by the simultaneous contrast with and similarity to his own sophisticated background and habits. Beggars, drunks, exiled Poles and other semi-tragic figures are shown using the local fairs and religious festivals as a means of loudly and ritualistically overcoming their alienation and frustrations:

> It is the renunciation & dissipation at stated times, of everything that a peasant has of disorder'd, exalted, that in us that will not be contain'd in ordinary life; all that there is left of rebellion against life, fate, routine in the peasant. All these people bring all their indignations, all their revolts, and bewilder'd dreams, and sacrifice them here, pay their supreme tribute to Fate, instead of keeping jealously their passions & reveries hidden in their hearts, they come here and fling all to the winds, leave themselves bare, make a bonfire of what the intelligence tells us is most precious. But ... certain of their emanations strain to each other as they perish; ... that that is most delicate, most inspir'd in each nature, & for that reason to be sacrificed as superfluous ... [6]

This creates a strange and complex impression – the Dostoyevskyan tragic vision, the hint of William Blake in the word 'emanations', the burlesque tone, the curious antiquated spelling and the real sense of Romantic identification matched by the modern anthropologist's remote observation. Already Lewis had identified habit and fate as inevitable enemies of the human spirit and forces which every effort should be taken to combat.

It was with these images and emotions struggling for expressive shape in his mind that Lewis, now something of a man of the world, began to leave behind what he later referred to as his 'cryptic immaturity'.[7]

3

'HOB-GOBLIN TRICKS' 1909–1912

Or, to take the symbolic vedic figure of the two birds, the one
watching and passive, the other enjoying its activity, we similarly
have to postulate two creatures, one that never enters into life, but
that travels about in a vessel to whose destiny it is momentarily
attached. That is, of course, the laughing observer,
and the other is the Wild Body.[1]

'An Extensive Programme'

Lewis ended his prolonged travels with a mind which had become cynical about the romance of bohemianism and of artists living freely in primitive settings, and with a highly original and paradoxical sense of the new circumstances in which art and life might now be conceived. Although he continued to travel frequently, Lewis settled in London in late 1908 and started in earnest his two-pronged career as artist and writer. On the one hand he submitted short stories and essays to leading literary journals such as *The English Review*, and on the other he began to exhibit with his friends Gore and Gilman in exhibitions of the Camden Town Group which operated under the wing of Walter Sickert. He also sought access to high society and patronage and continued his self-education in a range of disciplines, from psychology and politics to science and theology.

Against a volatile background of political and social unrest, indicated by the rise of the Suffragette movement, violent Syndicalist strikes and the Home Rule crisis, Lewis came into his own. He was fascinated by the ideas of radical political thinkers such as Georges Sorel, even if at this point in his life politics seemed more like a game than the destructive fire it became for him later in life. This period, during which, one historian has claimed, the 'strange death of Liberal England'[2] occurred, was a good time to make London the base for a high-profile career – the city was becoming a 'vortex' of cultural activity, attracting young British and foreign artists and writers such as Jacob Epstein and Ezra Pound, becoming a reinvigorated centre for nightlife and attracting considerable American financial investment. A scandal-hungry public was fed with endless reports of artistic and other outrage by a hyperactive press. The artist and critic Roger Fry's two Post-Impressionist exhibitions in 1910 and 1912 introduced Britain, rather belatedly indeed, to the more recent developments of French art. F.T. Marinetti's arrival in London with the Futurist movement during these years opened up a whole new field for controversy and action which exactly suited Lewis's temperament in his cultural fight with John Bull and his pursuit of what he mysteriously described to Sturge Moore as 'an extensive programme'.[3] His later remark to Roger Fry that he

was looking for some 'big belief' beyond art and his statement to a newspaper in 1913 that everyone required a little room for contemplation through art, give some hint of his interests.[4]

'Quite Impossible'

It was work such as *The Theatre Manager* (fig.2) which earned Lewis immediate notoriety and critical abuse when he exhibited with the Camden Town Group at their first exhibition in June 1911. Indeed, the painter Lucien Pissarro so disliked Lewis's paintings when he saw them that he threatened to withdraw from the Group, remarking, 'The pictures of Lewis are quite impossible!'[5]

In *The Theatre Manager* each one of the motley group of thespians has a grotesquely and clearly phallic elongated nose, the faces are mask-like, the bodies deformed and the awkward style adopted is derived from a bizarre mixture of Dürer, Gillray, and Picasso's proto-Cubist drawing. It crudely announces many of Lewis's artistic preoccupations – the search for a truly

2 *The Theatre Manager* 1909
Pen and ink, watercolour
29.5 × 31.5
(11⅝ × 12⅜)
Victoria & Albert Museum, London

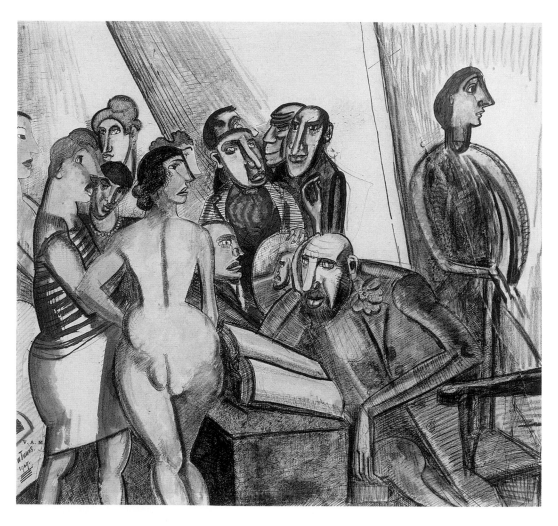

modern figurative art drawn from a range of sources, a philosophical critique of contemporary aesthetic and social ideas, and an intense satirical vision. The style was intended, almost as a juvenile obscene gesture, to provoke the sort of response it got from artists such as Pissarro. The subject matter referred both to the Edwardian stage world of London with its celebrity actor-managers familiar to everyone, and the subject of much painting such as Sickert's; and beneath the cartoon-like gesture of the piece there is a serious theme – the individual and the group, the artist and his fictions. The central seated bearded figure is almost collapsed in front of an open book as he ponders how to bring his unpromising cast into some dramatic order. Lewis, who had just finished an unpublished comic philosophical novel (published posthumously in 1977 as *Mrs Duke's Millions*) about a group of actor criminals in Soho in which identities are constantly switched to the point of utter farce, was preoccupied with the idea of how the mind manages its disrupted and fluid life. The actors are both individuals and parts of the manager's psyche, in either case acting as the unruly material from which art is formed. The open book, however, suggests an exasperating world in which a plot and script are always already written, limiting the scope for the order which the artist seeks.

In his short stories of this period, mostly drawn from his Brittany experiences, Lewis brilliantly evoked a comically alarming universe of minds struggling inside 'wild bodies', as he called them, and of egos obsessed with achieving safety in a solipsistic world and dominated by some often preposterous *idée fixe*. The artist, like a joker, plays with this absurd condition, but as a matter of spiritual life and death, in his role as commentator and guide:

> The practical joker is a degenerate, who is exasperated by the uniformity of life. Or he is one who mystifies people, because only when suddenly perplexed or surprised do they become wildly and startlingly natural. He is a primitive soul trying to get back to his element. Or it is the sign of a tremendous joy in people, and delight in seeing them put forth their vitality, and in practical joking of a physical nature a joy in the grotesque-ness of the human form. Or it is the sadness of the outcast, the spirit outside of life because his nature is only fit for solitude, playing hob-goblin tricks with men that cannot sympathise with him ... [6]

Lewis expresses a characteristic uncertainty about his position: on the one hand drawn to a loss of self in the dance of life, on the other resigned to a distant melancholy. What might seem to be simply an adolescent ambivalence is the basis of his mature philosophy of art and life in which the self struggles with its surroundings and itself in order to seek a consistency and wholeness which few achieve.

In *The Celibate* (fig.3), also painted in 1909, Lewis's line is far more geometrical and we see, no doubt, the remarkably precocious impact of Cubist art on his work. At the same time we see an alternative approach to the artist's condition. The figure seems to be dressed in classical garb, and its eyes look out through sharp slits as if from behind a metallic helmet. It seems likely that Lewis is staging here one version of the artist – intellectual, cold, ascetic.

Unlike the peasants of his Breton journals and short stories, or the man of the urban masses, the artist consciously and purposefully seeks to 'comprehend a great many people in an intellectual orgie ... the enemy of such orgaic participation in life, and often lives without proving the emotion felt in the midst of its wastefulness'.[7] *The Celibate* is notably androgynous, a necessary condition, perhaps, of this idealised figure, introducing a recurring theme in Lewis's art. Quite probably Lewis was responding to the idea in Sturge Moore's recent book *Art and Life* (1910) that 'the true artist should be a Nazarite, a priest' and 'has no right to live like other men'.[8]

By 1911 Lewis was able to work confidently within the new visual language of Cubism, as his delicate yet chilling watercolour *Self-Portrait* (fig.4) indicates. The mask staring at us is now that of 'Wyndham Lewis', the increasingly visible and charismatic, if inscrutable, presence on the London avant-garde

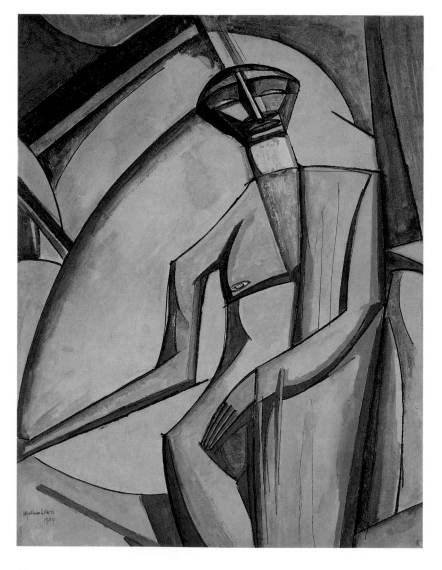

3 *The Celibate* 1909
Pen and ink,
watercolour and
gouache
37.5 × 28.5
(14¾ × 11¼)
Private Collection

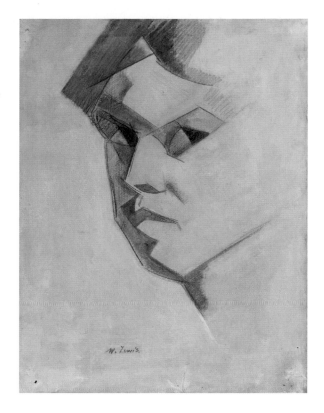

4 *Self-Portrait* 1911
Pencil, watercolour
30.5 × 23.5
(12 × 9¼)
Private collection, on
extended loan to the
Courtauld Institute of
Art Gallery, London

circuit, already unnerving his contemporaries with his behaviour, writing and art. His older friends such as Augustus John and Sturge Moore were anxious about his new mode, the latter saying he feared the young man was putting his 'head into a pudding bag, aesthetically speaking ...'.[9]

Works such as *Smiling Woman Ascending a Stair* (fig.5) of the following year put Lewis quite out of their reach and in the position of premier modernist in England. Here we see him creating a figure out of a sequence of straight and curved lines, almost 'carving' it out of the white and purple-grey background. Lewis claimed in a newspaper interview that the work (and a related but now lost six-foot multi-sheeted painting) was done from life, and in fact the grim-acing, aggressive masked features are those of Kate Lechmere, his lover and financial supporter at this time. On the left is part of another figure, holding a mask, suggesting a setting of a ball or similar event. Above all, Lewis further refines his staged world of masked actors, sending out mixed signals and insisting on life's artificiality and constructedness. It is likely that Lewis was making reference in this work to one by John, *The Smiling Woman* of 1908–9, and thus underscoring the now strong line between his work and that of his mentor. Where John painted a lush image of his lover Dorelia romantically dressed in gypsy costume, Lewis's lover-model, arms folded nonchalantly, plays an altogether more modern game of sexual display. John's portrait was painted for an exhibition called *Fair Women*, a title guaranteed to make his younger friend guffaw in derision. Lewis's work marks a powerful rupture with his immediate heritage, both artistically and sexually.

17

5 *Smiling Woman Ascending a Stair* c.1911
Charcoal, gouache 95 × 65 (37⅜ × 25⅝)
Private Collection

4

'COMPLICATED IMAGES' 1912–1914

A complicated image developed in his mind as he stood with her.
He was remembering Schopenhauer. It was of a Chinese puzzle of
boxes within boxes, or of insects' discarded envelopes. A woman had
in the middle of her a kernel, a sort of very substantial astral baby.
This baby was apt to swell. She then became *all* baby. The husk he
held was a painted mummy case. He was a mummy case too. Only he
contained nothing but innumerable other painted cases inside,
smaller and smaller ones. The smallest one was not a substantial
astral baby, however, or live core, but a painting like the rest.
= His kernel was a painting. That was as it should be![1]

1912 was the year Italian Futurism made its appearance in London and Lewis quickly responded to the movement's new ideas and forms as presented in exhibitions and by the provocatively histrionic appearances of its leader F.T. Marinetti. He was highly sympathetic to their radical attitude to modernity, their formal experimentation drawing on Cubism and their manipulation of the mass media for a confrontational relationship with the general public. He was a knowledgeable and critical reader of the philosophers the Futurists admired, such as Henri Bergson and Friedrich Nietzsche, and shared their curious combination of nascent anarchist and authoritarian politics. Thus far he might be called, as he and others often were, an 'English Futurist'. A close examination of Lewis's art and thinking, however, reveals some deep divisions which render the designation improbable, as well as objectionable to Lewis.

Firstly, Lewis rarely sought to convey his sense of modernity by celebrating the typical Futurist subject matter of cars, aeroplanes, industrial activity and so on. He saw this imagery as passé and vulgar, preferring to invent figures whose means of representation rather than superficial characteristics were 'modern', capturing the quality of the contemporary more subtly. The first efforts at this can be seen in one of his most overtly industrial works, the transitional *Two Mechanics* (fig.6) of 1912. The two clumsily sculptural figures, set in a bare, abstracted landscape, are tragic victims of their bodies and fates. Here are elemental types, quite delicately drawn, who have the strangely mixed quality of both man-made totems and muscular proletarians. They might be primitive wooden icons from Brittany as carved in a backstreet motor workshop in Camden Town. They seem to be from a different universe and yet are unmistakably human in their bearing and their setting has the colour and feeling of somewhere recognisably urban and raw. Lewis, as ever, confuses expectations and yokes different visual languages together in order to get to some aesthetic point which is hard to define.

6 *Two Mechanics* 1912
Pen and ink, wash 56 × 33.5 (22 × 13¼)
Tate

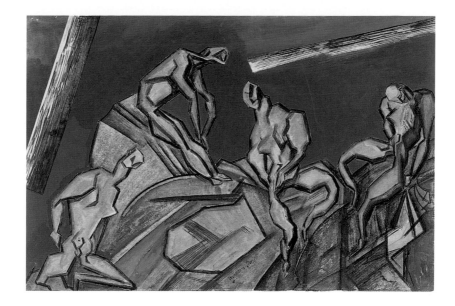

7 Sunset Among the Michelangelos 1912
Pen and ink, gouache
32.5 × 48
(12¾ × 18⅞)
Victoria & Albert Museum, London

As in his *Sunset Among the Michelangelos* (fig.7), also of 1912, there is a nervy shifting of registers, as though the artist is ironically tracing the epochal transformation from one artistic tradition, now in collapse, to another seeking realisation – from Tonks to Picasso, as it were. What seemed to Pissarro and others to be a pucrilc joke has become something both powerfully serious and yet wittily suggestive of new horizons. The impact the now lost *Kermesse* made when seen in 1912 at Madame Strindberg's short-lived avantgarde decorated nightclub, the Cave of the Golden Calf in the West End, underlines the impression Lewis was making across the art world in this critical year. Roger Fry, Clive Bell, Augustus John and Walter Sickert all realised, pcrhaps with surprise, that a major talent had arrived with this work.

In *Study for Kermesse* (fig.8) a central male and female pair of dancers at a 'kermesse', or country dance, seem to be caught in a fatal embrace, engaged in a sexual ritual reminiscent of the Dionysian orgies Lewis had encountered in his reading of Nietzsche, in which the spirit seeks release from matter into an ecstasy of cosmic union – a union Lewis doubted was advisable or attainable. His description of Breton kermesses in his journal of 1908 presents a world of tragic and claustrophobic exuberance: 'The world must not distend with our spirits, if we are to be gay: if material life grew larger and fairer materially and not only by the spell of our imagination, in our moments of inspiration we should not feel the interior change, and have no measure by which to judge the greatness of our souls ...'.[2]

Secondly, although stylistically clearly indebted to Umberto Boccioni's drawings of 1912, Lewis takes his source and transforms it in the interests of an entirely different set of meanings. This can be seen most dramatically in his magnificent suite of drawings for an edition of Shakespeare's *Timon of Athens* (fig.9), made on a trip to France in 1912. (Typically of Lewis's accident-prone career, the new edition of the play was not published and he had the drawings produced as a separate portfolio.) The subject, one of Shakespeare's lesser-

known plays, is in itself significant. A narrative from classical Greece is hardly the stuff of Futurist fantasy and it is as if Lewis was deliberately pointing up the futility of obsessive contemporaneity. That the character Timon is a foolishly generous soul whose cruel treatment by supposed friends leads to a self-destructive anger and misanthropy, is equally significant. While Lewis could be sentimentally convinced of his own hurt virtue, he also believed such responses to misfortune and disappointment in others to be a weakness, as he explained in 1927 in his book on Shakespeare and Machiavelli, *The Lion and the Fox*. The main colour plates of the portfolio are works of enormous energy and formal vigour and, while suggesting a world of dynamism and interaction similar to that of Futurist art, remain tight and sharp with their arcs and cutting lines. In *The Thebaide* (fig.10) the soldier Alcibiades and two whores occupy the centre of the composition, confronting the screaming Timon who seems to be sucked into Lewis's network of linear forces as if by the relentless power of the material world he rejects. Lewis has moved from the austere, voided landscapes of his previous work and a briefly imagined world of absurd dancing figures, to a matrix of structures, human and non-human, which shapes and determines the fates of its inhabitants. Here was a visual language which could begin to embody fully his emerging ideas about mind and world, self and not-self. It is not clear if Lewis had read Karl Marx's analysis of *Timon* as a critique of the effect of the 'cash-nexus' on human relationships, but Lewis was familiar with Marx by this period and his other writing contains penetrating analysis of the function of money in psychological terms. He would also have been deeply interested in the debate in the play about the relative merits of the literary and plastic arts, a matter of continuing concern as he pursued his dual career. The *Timon* drawings are the first of a number of attempts by Lewis to reinvent the academic category of 'history painting' and to use it to deny that there is truth in action.

Below left
8 *Study for Kermesse* 1912
Pen and ink, wash, gouache
35 × 35.1
(13¾ × 13⅞)
Yale Center for British Art, New Haven

Below right
9 *Timon of Athens: Act III* 1912
Reproduced from *Timon of Athens* Portfolio 1913
Tate Archive

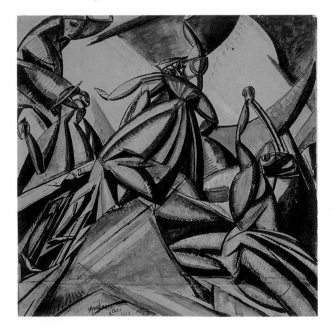

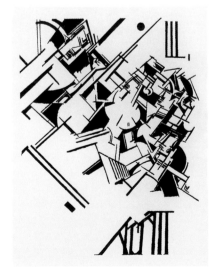

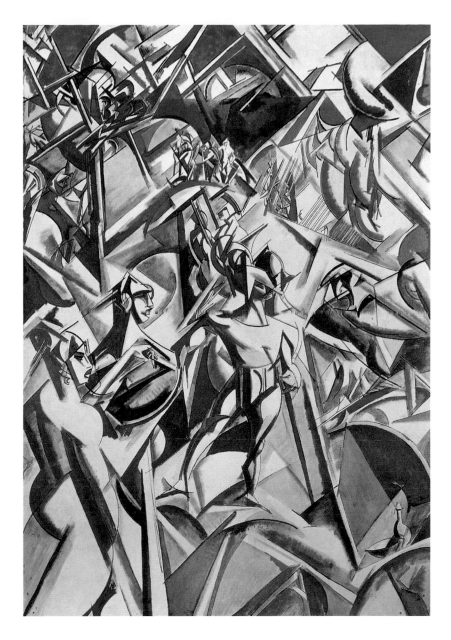

'Subjective Intellection'

The years 1913 and 1914 were a high point in Lewis's activities as an artist. He developed into one of Britain's most adventurous and impressive modernist artists and gained an international reputation; he set up a rival organisation to Roger Fry's Omega Workshops, the Rebel Art Centre; he became a fashionable interior designer and newspaper celebrity; he founded an art movement, Vorticism, and edited its journal *Blast*. It is also the period in which he most closely approached a fully 'abstract' expression, although this is a misnomer if used to convey the idea of an art devoid of content and figurative allusion.

Lewis was rapidly moving away from his Camden Town Group affiliations and his uneasy relationship with the Bloomsbury artists such as Roger Fry and Duncan Grant was irrevocably severed when he became embroiled in a bitter dispute with Fry which still reverberates today in the British art world. Who did what or said what will never be entirely clear, but Lewis took exception to what he saw as underhand behaviour by Fry over a commission from the *Daily Mail* for the Ideal Home Exhibition in the autumn of 1913, and instigated a schism within the ranks of London's modern-art scene with a round robin letter. In this he denounced Fry's perfidy and attacked what he regarded as effete Bloomsbury amateurism and cultural conservatism. The immediate result of this action was that he assembled a loose group of artists, including Edward Wadsworth and the French sculptor Henri Gaudier-Brzeska, who were sufficiently disenchanted with Fry and suitably radical in their artistic trajectories to feel that a new association might be of benefit to their careers. The first-floor rooms of the newly founded Rebel Art Centre in Great Ormond Street became a base for Lewis's operations over the next year. The centre generated some important work by all involved and got much press attention as the latest fad in contemporary art, but as the intended rival in modern design to the Omega Workshop it was a failure. It also failed in its ambition to be an art academy, attracting only two students, and was doubtless hampered by Lewis's poor business instincts and inability to manage his personnel.

Another well-publicised dispute was with Marinetti, who in 1913 and 1914 sought to coordinate a group of English Futurists along colonialist lines. This was a profound mistake, especially when he used Lewis's and other artists' names on a manifesto announcing the formation of such a group. Much as Lewis was indebted to the new media-driven Italian cultural revolution, he was at odds with its overarching philosophies and anyway could not accept another man as a leader of English avant-gardism. The public rows with Fry and Marinetti thus gave Lewis the impetus to define his aesthetic position in paint and print at a dramatic moment in European artistic and political history. He accepted the challenge and ensured his place in the accounts of that history.

Vorticism was a short-lived movement which was highly controversial at its inception and was still causing trouble when, the year before his death, Lewis claimed to be its sole instigator at an exhibition at the Tate Gallery in 1956. The term Vorticism derives from a concept of the 'vortex' which seems to have been the American poet Ezra Pound's idea, itself derived from occult and linguistic sources of a kind familiar in avant-garde circles. By 1913 Pound was closely involved with Lewis and his allies and was pushing his own literary form of modernism through 'Imagism', a movement which shared much conceptual and aesthetic ground with Vorticism. Along with the renegade philosopher, poet, art critic and translator of recent continental theory (and a sexual rival of Lewis), T.E. Hulme, Pound sought a new language for poetry based on the directness of visual perception and indebted to Chinese and Japanese art and literature. His fascination with Noh and Kabuki drama, haiku poems and the 'six canons' of Chinese art theory was entirely in tune with Lewis's own interests. Both men were friends and even protégés of

Laurence Binyon, the founding Keeper of a new department of Oriental art at the British Museum, who had written an influential book on the subject, *The Flight of the Dragon*, in 1912.

Lewis's own interest in Far Eastern art can be discerned as early as 1912 in his watercolour now known as *The Vorticist* (fig.11). A figure, stylistically close to those of the *Timon* series, seems blindly and furiously to strike a martial pose, defined by Lewis's trademark arcs and sharp straight lines. Set against a pale background, the figure is reminiscent of those in Japanese woodcuts and perhaps like an armoured Kabuki actor of the kind making appearances at London venues at that time. The subtle washes and areas of pastel achieve a

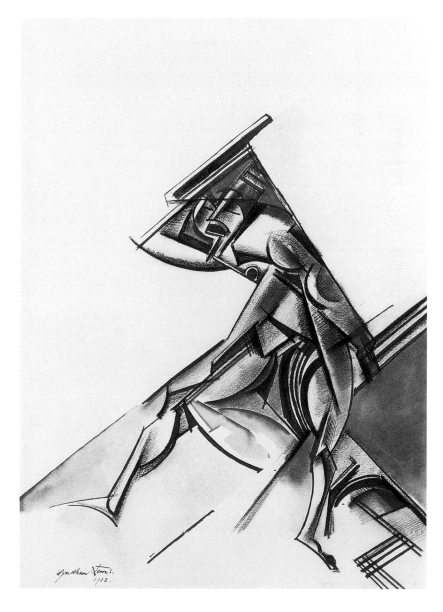

11 *The Vorticist* 1912
Pen and ink,
watercolour
41.4 × 29.4
(16¼ × 11⅝)
Southampton City
Art Gallery

delicacy for which the term 'oriental' does not seem misplaced. Throughout his career Lewis learnedly used Chinese and Japanese art, and their yogic disciplines, as an inspiration.

Lewis had started to make images which by 1913 have a curiously 'compacted' quality, carrying an emblematic or heraldic latency of allusion which is unique in art of the period. This derives in part from his interest in Imagist theory, including Pound's emphasis on the power of Chinese ideograms, and also probably from a quasi-occult background of 'word magic', kabbalistic and other varieties of which were current in Edwardian London. Lewis was clearly taking note of the Russian painter Wassily Kandinsky's aesthetic ideas, and although he was usually scornful of most varieties of spiritualism he had a persistent attraction to metaphysical and theological interpretations of reality. He gave a lecture to the occultist Quest Society in 1914 and in a press quote said:

> The spiritual world is the Polar regions of our psychic existence, and useful ghosts will meet us on its borders, even if we do not adventure more. I have been struck lately in reading how the Chinese Geomancers, when they are called in to heal sick people, instead of diagnosing in the ordinary way, show that a mountain's shape above the house, the volume of a lake or its colour, or perhaps the elevation of a street had an occult and unfavourable influence on the being living near it. All these forces are the material of modern art.[3]

Lewis's reputation as a 'hard man' of satire has often obscured this central role of occultist thought in his work. Lewis was not a believer in table-tapping

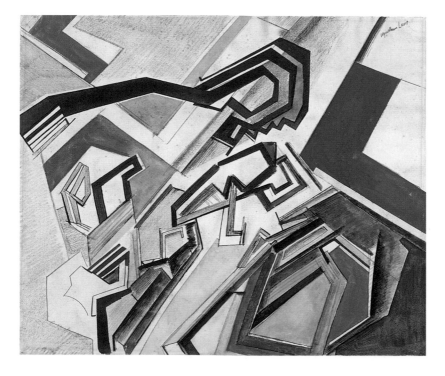

12 *Planners (A Happy Day)* 1913
Pencil, pen and ink, gouache
31 × 38 (12¼ × 15)
Tate

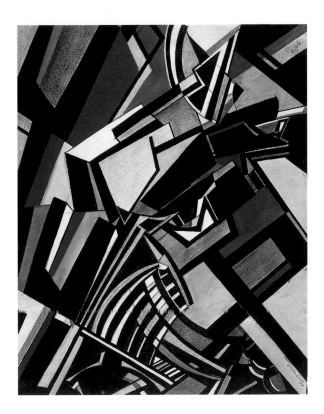

13 *Composition* 1913
Pencil, pen and ink,
watercolour, collage
34 × 26.5
(13⅜ × 10⅜)
Tate

or levitation, but rather saw the artist's close engagement with the material world as a complex relationship with psychic and metaphysical realities. Without this visionary impulse he believed art would be inert naturalism or mere 'significant form', lacking in the complexity and beauty he was seeking. Talking later of his classic Vorticist work, he explained that 'a mental-emotive impulse (by this is meant subjective intellection, like magic or religion) is let loose upon a lot of blocks and lines of various dimensions, and is encouraged to push them around and to arrange them as it will. It is of course not an accidental, isolated, mood: but it is recurrent groups of emotions and coagulations of thinking, as it were, that is involved.'[4]

Planners (A Happy Day) (fig.12), painted in 1913, may be an image of this aesthetic activity, while also showing Lewis's growing concern with the world of architecture and its social and political contexts. At the centre of the watercolour a highly geometricised figure of a draughtsman, head resting on a bent arm, seems to be overshadowed by a larger, maybe threatening, presence within a world of 'blocks and lines of various dimensions'. Typically of Lewis's art, there is a teasing suggestion of readable forms which never quite allow for clear definition. Maps, street corners and distant views seem to emerge and then recede in our perception.

As Lewis said, his procedures were expressive of a dominant mood – he always insisted on the emotional and metaphorical power of colour beyond its descriptive function – and an entirely different atmosphere is created in the dark claustrophobia of *Composition* (fig.13) of the same year. Here the

aesthetic 'magic' ritual has produced an image suggestive of an armoured head, or skull, which also evokes a mechanical or military presence. The pastel and pencil shades have the quality of smoky and grimy urban surfaces. And yet, as has been plausibly suggested by various commentators, we are also looking at a dancing couple of the sort Lewis had already painted – a Dionysiac couple from a London dance hall perhaps, locked in a desperate routine such as the popular 'Apache' dance.[5] Along with the hints of aerial photography and city maps, the work generates a dizzying range of allusions, as if through some cunning camouflage. The more one looks at such works the more one sees emerging phantoms in the mind's eye, and yet the less the visual language sustains fixed readings or allows for psychological comfort – just as Lewis, or his unconscious will, intended a talismanic art should do. Perhaps it is no coincidence that J.F.C. Fuller, the military theorist and commander of British tank strategy in the war which was shortly to change Lewis's life, developed an early 'blitzkrieg' strategy, in part, from his understanding of his mentor Aleister Crowley's magical system. A lost major canvas of 1913 was indeed called *Plan of War*, and the reproduction which survives suggests an image of 'psychic attack'.

Lewis's work of the period 1913–15, therefore, breaks entirely new ground, exceptional in the context of British art at the time, as he worked a series of brilliant variations on some core themes and concepts – vertiginous intimations of New York, feminised premonitions of later Russian Constructivism (fig.14) and emblems of industrial power among the strangely coloured and densely composed watercolours and drawings which survive. Some have a heavy and opaque congestedness, like a city or a crowded mind pursued by 'coagulations of thinking', others a distant delicacy and clarity, like dreams of escape or rapidly sketched utopian fictions.

Composition in Blue 1915 (fig.15), for instance, shows a figure constructed from its urban surroundings, with hints of simple black girders and a chilly blue sky – or a patch of watercolour – beyond. The figure's helmet-like head is akin to the Chinese puzzle Lewis refers to in *Tarr*, revealing perhaps a painting at the centre of a mind which makes and is made by the world it inhabits. Many of Lewis's Vorticist drawings are seemingly elementary and skeletal affairs, drawn with a pencil and ruler as try-outs for canvases which, whether executed or not, are almost all now lost (fig.16).

Below
14 *An Englishwoman*
1913–14
Graphite, gouache, paper
56 × 38 (22 × 15)
The Wadsworth Athenaeum Museum of Art, Hartford, Connecticut. The Ella Gallup Sumner and Mary Catlin Sumner Collection Fund

Opposite
15 *Composition in Blue* 1915
Chalk and watercolour
47 × 30.5
(18½ × 12)
Private Collection

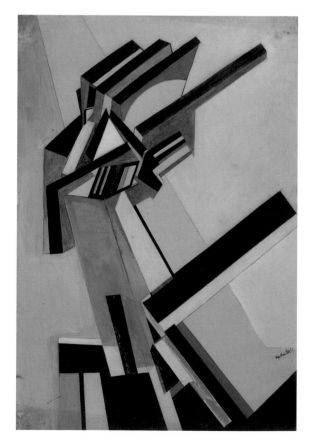

28

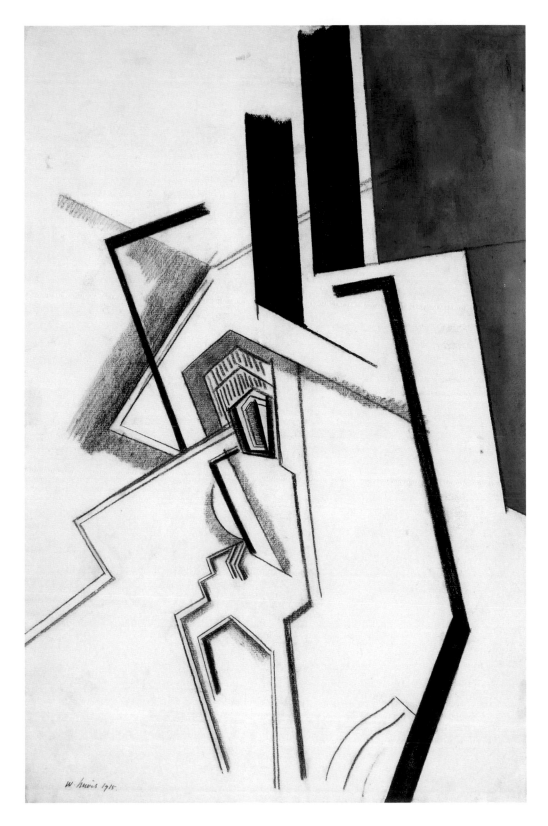

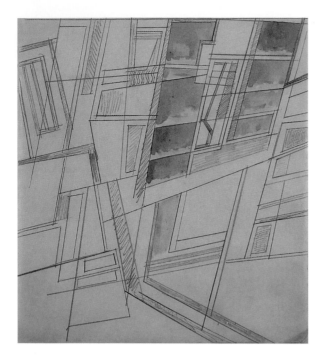

16 *Vorticist
Sketchbook
Composition 3*
1914–15
Offset lithograph on
paper
29.2 × 26.7
(11½ × 10½)
San Francisco
Museum of Modern
Art. Fractional gift of
Bobbie and Mike
Wilsey

'Blast England'

Lewis and his Vorticist colleagues from the Rebel Art Centre, along with a number of important figures at the periphery of things, published the first of two issues of the magazine *Blast* in July 1914, shortly before the outbreak of war. *Blast*, a thick puce-coloured volume with stark black lettering across the cover and its pages dominated by a bold new typographical approach indebted to Futurist example and the London popular press, is a form of artwork in its own right (fig. 17). Containing manifestos, photographs of paintings and sculptures, poems, short stories and essays and national provocations, it is without question one of the great documents of European modernism. Although the idea of the distilling and concentrating 'vortex' was Pound's and the mildly expletive title Christopher Nevinson's, *Blast* is substantially the work of Lewis, its editor and primary intellectual driving force.

The vortex itself summoned up, among a number of themes, the idea of the creative mind, a modern source of energy and the magnetic power of London as a cultural capital attracting figures from around the world. Lewis indulges in a fair degree of nationalist posturing, pointing out, for example, how the British were the first industrialised nation and should avoid Italian excitability about modernity. As Lewis's biographer Paul O'Keeffe has shown, the strange 'lampshade' symbol for the vortex deployed in *Blast* is derived from the storm canvas cones used by ships to warn of storms – in this case indicating one coming from the north. This is, light-heartedly, significant – Lewis is countering what he saw as a Mediterranean flow of artistic energy with a distinctly northern, specifically English, one. *Blast* includes a highly favourable review by Lewis of an exhibition of German Expressionist woodcuts and the leading

Berlin Expressionist journal was *Der Sturm*, clearly an influence on the title and contents of the London magazine.

Lewis attacked British culture for its 'mildness', blaming this conservatism on a susceptibility to the influence of the Gulf Stream. Bergson, Elgar, the 'Clan Strachey' and various popular entertainment figures are among those singled out for humorous attack. British humour is both 'blasted' and 'blessed' as a denial of seriousness on one hand and, on the other, as a satirical 'barbarous weapon' expressing itself in 'the separating, ungregarious BRITISH GRIN'. The question of the 'New Egos' appropriate for modern life is, as our examination of Lewis's art of this period has shown, at the heart of much of his thought and the subject of one of the short aphoristic essays he contributed to the new journal. In an egotistical world with an 'infinite variety of means of life ... frontiers interpenetrate, individual demarcations are confused and interests dispersed'. The simple individualities of the past are no longer a sufficient model for life and art cannot continue as if 'the one compact human form' is sufficient as a means of expression. A new 'logical Passion of Life' is thus the foundation and aim of a new art, where a 'separating' instinct must live alongside a psychological 'promiscuity'. Lewis accepts the Futurist diagnosis of the flux of modern life but proposes an imaginative independence from, rather than an immersion in, it. Equally, he rejects the Futurist concept of 're-constructing the universe' and mocks their 'automobilism' and efforts at fashion design.[6]

BLAST First (from politeness) **ENGLAND**

CURSE ITS CLIMATE FOR ITS SINS AND INFECTIONS

DISMAL SYMBOL, SET round our bodies,
of effeminate lout within.

VICTORIAN VAMPIRE, the **LONDON** cloud sucks
the TOWN'S heart.

A 1000 MILE LONG, 2 KILOMETER Deep

BODY OF WATER even, is pushed against us
from the Floridas, **TO MAKE US MILD.**

OFFICIOUS MOUNTAINS keep back **DRASTIC WINDS**

SO MUCH VAST MACHINERY TO PRODUCE

THE CURATE of "Eltham"
BRITANNIC ÆSTHETE
WILD NATURE CRANK
DOMESTICATED
POLICEMAN
LONDON COLISEUM
SOCIALIST-PLAYWRIGHT
DALY'S MUSICAL COMEDY
GAIETY CHORUS GIRL
TONKS

17 Page from *Blast*
No.1, July 1914
Tate Archive

'Toppling Byzantine Organ'

In many respects Lewis's most remarkable written contribution to *Blast*, more so even than the highly original and distinctive manifestos, sweeping insightful reviews of avant-garde movements and art criticism, was his Vorticist drama, *Enemy of the Stars*. Impatient with the intellectual limitations of Imagism and convinced that major cultural change required intense language experimentation, he wrote this extraordinary piece as a challenge to the other writers published in *Blast* such as Pound and Rebecca West. Some idea of what this attempt aimed at stylistically can be gained from the following passage:

> Fungi of sullen violet thoughts, investing primitive vegetation. Hot words drummed on his ear every evening : abuse : question. Groping hands strummed toppling Byzantine organ of his mind, producing monotonous black fugue.
>
> Harsh bayadere-shepherdess of Pamir, with her Chinese beauty: living on from month to month in utmost tent with wastrel, lean as mandrake root, red and precocious : with heavy black odour of vast Manchurian garden-deserts, and the disreputable muddy gold squandered by the unknown sun of the Amur.[7]

This often seems nearly impenetrable, yet it compels attention – there is no alternative, as with much of Lewis's work, but to concentrate and work against the resistance of the mind's apathy. Even the hero Arghol's name is densely allusive – referring to the double star Algol in the constellation Perseus, to an archaic term for an astrologer's manual and to Argol, a place in Brittany and the term for the residue of wine fermentation or 'tartar' (hence perhaps the name of Lewis's first novel, *Tarr*).

Enemy of the Stars is instructive for understanding Lewis's art in a number of ways: thematically, technically and emotionally. Based in part on Lewis's experiences as a student in Germany, it evolves into a violent dramatisation of psychological conflict set in a Manichean world of occult forces, the 'stars', and chilly arctic spaces – a wheelwright's yard in 'the North'. It undoubtedly draws on Marinetti's writings, but also on William Blake's prophetic books such as *Jerusalem*. It works, therefore, in a typically Lewisian fashion, drawing in and compacting in unusual form myriad sources. The central characters, Arghol and Hanp, represent the authentic and inauthentic selves, condemned to a deadly, ambiguously sexual dance around one another. Lewis's scepticism about simplistic Romantic dualities is revealed in Arghol's angry destruction of a 'poodle of the mind', the anarchist book he had allowed to overwhelm his mind, Max Stirner's *The Ego and His Own* (1844). However, there can be little doubt that in staging the 'agon', or duel, between his two protagonists as that between the artist and phantom 'Humanity', Lewis is powerfully stating his position as defender of the artist's elite role as 'sacred prostitute', contaminated by the world but in deadly combat with it. The confusions of identity, noted previously in Lewis's work, are here pushed to an extreme as Arghol realises that there is no 'escape' from the world, that he is condemned to

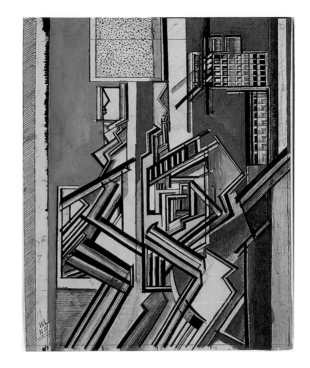

18 *Design for Red
Duet* 1915
Pencil, pen and ink,
watercolour and
gouache
31.5 × 25
(12⅜ × 9⅞)
Private Collection.
Courtesy Jeffrey
Deitch

doubleness. Thus the world and its vulgar, gregarious triumph is indispens-
able to the artist, who must not feebly turn aesthete but instead immerse
himself in the messy, dirty business of life.

Lewis's work of 1913 to 1915 often relates directly to the concerns of this
pioneering literary work. *Red Duet* (1914) and *Design for Red Duet* (1915)
(fig.18) are visual dramatisations of the work's dominant themes of duality.
The former's colour scheme perhaps suggests the 'red walls of the universe'
which first shut the antagonistic pair in their 'bleak circus' and which then,
after Arghol's murder by Hanp and the latter's suicide, recede. Both works,
and in particular the oddly blue *Design* (for a now lost canvas), are most
clearly understood in relationship to an essay in the second issue of *Blast*
(1915) called 'Wyndham Lewis Vortex No.1: Art Vortex: Be Thyself', in which
he exhorts the reader to be 'a duet in everything', accepting psychological
plurality and dealing with it in a dialectical fashion by starting 'from opposite
statements of a chosen world':

> You can establish yourself either as a Machine of two similar fraternal
> surfaces overlapping.
> Or, more sentimentally, you may postulate the relation of object
> and its shadow for your two selves ...
> You must catch the clearness and logic in the midst of
> contradictions: not settle down and snooze on an acquired, easily
> possessed and mastered, satisfying shape.

Art, and the life that sustains it, involves a constant battle with habit and
thereby attains to what Lewis described as 'something very abstruse and
splendid', not an 'equivalent for life, but another life.[8]

5

'MONSTROUS CARNIVAL'
1915–1919

The Colonel ... sent for me ... to ask me what 'Imagisme' was.
With my rifle at the slope I explained as best I could. But the Colonel
said that I would never make him understand such things, and
carrying my right hand smartly across the body, I placed it, palm
downwards on the small of the butt: then cutting it smartly to the
side, took a step to the rear, and turning rapidly about, moved back
to continue the instruction of my men.[1]

At the outbreak of the First World War, which he described as a 'monstrous
carnival' produced by Germany's thwarted desire for France, many of Lewis's
friends and close professional acquaintances were enlisted and eventually a
number lost their lives in the conflict, Gaudier-Brzeska and T.E. Hulme being
two notable fatalities. Lewis, due to another outbreak of venereal disease
and an understandable reluctance, did not join the army immediately. He con-
tinued to pursue his literary and artistic career, greatly supported by Pound,
who acted as go-between in arranging the purchase of paintings by the
American collector John Quinn, and in organising a Vorticist exhibition in
New York in 1917. Lewis decorated the Vorticists' favourite restaurant, La
Tour Eiffel in Fitzrovia, and also finished the novel he had put to one side a few
years earlier, *Tarr*, a satire on bohemian life in Paris and a major vehicle for
presenting Lewis's artistic credo.

The Crowd Master

Lewis's response to the mobilisation of British society, the war fever of 1914
and the onset of hostilities was that he became more fully politicised in his out-
look. His philosophical and psychological analysis of human behaviour in the
local settings to which he had so far limited himself was transformed by a con-
sideration of the international political scene and the economic and ideologi-
cal forces shaping it. This was a critical moment for Lewis as it propelled him
into regions from which there was no easy withdrawal, entrenching a fatal
fascination with power and ultimately confirming his outsider status for the
rest of his career.

His only surviving large Vorticist canvas, *The Crowd* of 1914–15 (fig.19),
makes this change abundantly clear. The densely subjective articulations of
self and not-self of the previous two years or so are, at least briefly, put aside
in favour of something almost diagrammatically representational. A vast
grid-like space in 'Byzantine' red and dull golds indicates a cityscape domi-

19 *The Crowd*
1914–15
Oil on canvas
198 × 152.5
(78 × 60)
Tate

nated by skyscrapers and girders. In the foreground large robotic figures push shut a door beyond which the revolutionary 'crowd' of conjoined stick figures move towards the top right corner where there seem to be slaves on a treadmill. The rigid and awkward vertical geometry suggests an alienated world, perhaps created by 'planners' on a 'happy day', in which individuals are subsumed into their environment. The second 'War Number' issue of *Blast* in July 1915 contained a story by Lewis called 'The Crowd Master', at the opening of which the main character observes the London crowds responding to the outbreak of war, drifting in 'thrilling masses'. It is a bleak experience as the police 'with distant icy contempt herd London. They shift it in lumps here and there, touching and shaping with heavy delicate professional fingers.' Lewis's earlier ideas had been enlarged politically both by events and, it seems certain, an acquaintance with the psycho-sociological writing of Gustave Le Bon, a French author read by many in the early twentieth century, including Freud and Hitler, who had written a book called *The Crowd* translated into English in

1896. Le Bon, from the political right, saw modern western democracies as complex manipulations of the masses by elites through education and the media, working on the innate weakness of the mass-mind and exerting a subtle hypnotism which created an unconscious consensus.

It is not hard to see how such ideas aligned themselves with Lewis's as he sought to understand the outbreak of war and the profound emotions it provoked, bringing into focus for him the difficulty of both being in the crowd, and thus having knowledge of it, but not being part of it. His aim in *The Crowd*, therefore, was to describe this 'huge indefinite Interment [*sic*] in the cities', avoiding the Futurist impulse to identify with and merge with the 'mass mind'.[2]

Few critics understood the purpose of the almost prophetic large canvas when it was displayed alongside Lewis's *Workshop* (fig.20) and other painters' works at the

London Group exhibition at the Goupil Gallery in March 1915, one suggesting that it was disloyally 'Prussian in spirit', executing 'a kind of goose-step where other artists are content to walk more or less naturally'. At a deeper level they may have realised the unpalatable truth of Lewis's perception that 'the Crowd is an immense anaesthetic towards death'.[3]

'Despicable Inhuman Swindle'

Lewis joined the Royal Garrison Artillery and in March 1916 arrived at Fort Burgoyne, Dover, as 'Gunner Lewis 71050', an official number in the crowd ready for training. In May 1917, having tried to put some order into his complicated private affairs and having written a full inventory of his writings and art, he was shipped to the Western Front as a Second Lieutenant. His experiences as an observer with a battery of howitzers near the Ypres salient are recounted in letters, short stories and in many darkly hilarious episodes in his first autobiography, *Blasting and Bombardiering* (1937). Clearly the experience at the time was harrowing, as he told Pound in a letter in June in words reminiscent of those used to describe the crowds in 'The Crowd Master': 'A watchfulness, fatigue and silence penetrates everything in it. You meet a small party of infantry slowly going up or coming back. Their faces are dull, their eyes turned inwards in sallow thought or savage resignation; you would say revulsed, if it were not too definite a word.'[4]

After an episode of trench fever and convalescence in Dieppe, where he was able to do some drawing and writing, he was posted to 330 Siege Battery in

time for what was perhaps the worst battle of the war, the massive artillery exchanges at Passchendaele which reduced the landscape to a treacherous and insanitary swamp. The experience left Lewis, who survived it intact, bitterly resentful of the 'despicable inhuman swindle' of the war and far more sympathetic to the fate of the average man who had previously been obscured to him in 'the Crowd'. His recruitment as an official war artist for both Canadian and British schemes was a merciful escape from the conflict, and fellow officers he couldn't abide – 'may their next fart split up their backs, and asphyxiate them with the odour of their souls!' he wrote to Pound when describing their taste in music.[5]

Lewis produced a remarkable body of work in 1918 and 1919, in spite of serious illness through influenza and double pneumonia, including the two largest canvases of his career. His war drawings are vigorous works, mostly in pen and ink and watercolour, in which the condensed forms of the pre-war oeuvre are transformed by a muscular figuration indebted to both Signorelli and to Japanese art. Like his Vorticist works, Lewis's war art shows the forces which turn a man into a specialised machine or functionary, as with the straining teams of men working with 3-ton howitzers in *Drag-Ropes* (fig.21).

21 *Drag-Ropes* 1918
Pencil, pen and ink,
watercolour
35.5 × 41.5
(14 × 16⅜)
Manchester City Art
Galleries

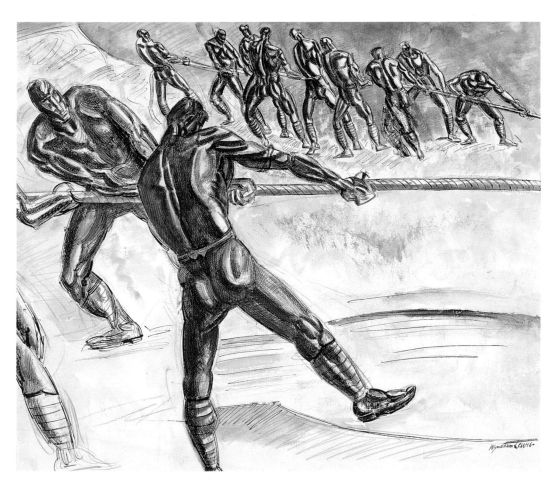

He described these drawings as part of a Hogarthian 'progress' of a gunner when he showed them in 1919.

Lewis identified two equally valid approaches to war painting – the passionate anger of Goya in his *Desastres de la Guerra*, and the cool, inhuman grandeur of Uccello, whose *Battle of San Romano* is a well-known masterpiece at the National Gallery in London. Lewis's work inclines to a steely detachment, but there is real empathy in many of his figures, and above all he wanted to convey the stark human realities of mechanised conflict rather than a sentimental humanism of easy disgust and pathos. The men at work are shown as if in a hellish factory or work compound, following orders whose rationality they do not question and for whom emotion is an unaffordable luxury.

A Battery Shelled (fig.22) caused great controversy when exhibited at the Royal Academy and prompted the criticism that it was 'inappropriate' for its theme and intended setting in a memorial hall. Today one would beg to differ; in 1919, Lewis's depiction of insect-like activity in a macabre but stylised landscape, observed by three indifferent foreground figures, was nearly unacceptable, heightening the horror of the scene by its very lack of formulaic posturing or heroism. The nonchalance contrasted with the formalised industrialised scenery, partly drawn from a screen he admired by the Japanese artist Korin, where, among other frenetic activity, an injured or dead man is carried away by colleagues, was an affront emotionally rather than stylistically. Lewis's own unease and sense of guilt at leaving his men in order to paint their predicament is made clear in *Blasting and Bombardiering* when he writes: 'My mind was forlorn as I said good-bye to my untidy little batman. I was like the heartless young squire bidding a last farewell to the simple village maid he has betrayed, beside the cottage gate.'[6]

22 A Battery Shelled
1919
Oil on canvas
182.7 × 317.7
(71⅞ × 125)
Imperial War
Museum, London

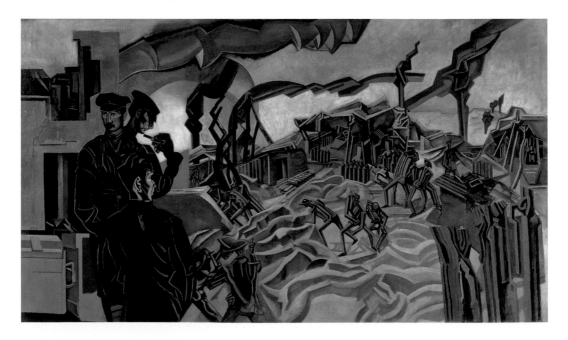

6

'WHAT IS THIS PLACE WE ARE IN?' THE 1920s

> When at some moment or another in the process of evolution we
> were introduced to the extraordinary Aladdin's Cave, that paradise ...
> *our minds*; or when the magnificent private picture-gallery of its
> stretched-out imagery was thrown open, and we were allowed to
> wander in any direction, and to any private ends we pleased; that was
> certainly, if it is the gift of a God, a highly democratic proceeding on
> His part: especially when you consider that this is not *one* picture-
> gallery, thronged by a swarming public, but is *one-apiece* for any
> number of individuals – the conception of so democratic a God that
> He became aristocratic again, as it were, for the sake of others.[1]

Following his war art commissions and a drawings exhibition called *Guns* at
the Goupil Gallery in early 1919, Lewis hoped for a revival of the pre-war ener-
gy and activity of Vorticism. He came into some money on the deaths, in rapid
succession, of his parents and, even given his commitments to a number of
children and their mothers, he had some financial stability at this stage; how
he managed to return so quickly to poverty, and thus become petulantly
dependent on funds from a group of supporters such as Edward Wadsworth
and the writer Sidney Schiff, remains something of a mystery.

'The Role of Line in Art'

Lewis was drawing from life incessantly, lecturing at the adult education
organisation the Arts League of Service, and publishing a portfolio of draw-
ings as well as articles on modern art. This activity produced two major initial
projects: the formation of 'Group X', a loose grouping of former Vorticists and
others unsympathetic to what they saw as the dominance of Roger Fry and
Bloomsbury aesthetics in the London art scene, but which disbanded after one
exhibition in March 1920; and the publication in October 1919 of *The Caliph's
Design: Architects! Where is Your Vortex?* a call for the integration of art, archi-
tecture and design in the name of a renewed British modernist vision. *The
Caliph's Design*, which begins with a parable in which the Caliph in Baghdad
demands a new Vorticist city from his architects on pain of death, includes a
radical attack on the amateurism and lack of intellectual ambition which
Lewis saw in much contemporary art, including that of Picasso.

Lewis, as ever, was in touch with the most recent continental developments
and was familiar with the Purism of Léger in Paris, the De Stijl movement in
Holland, and Dadaism and Constructivism in Germany and Russia. At one

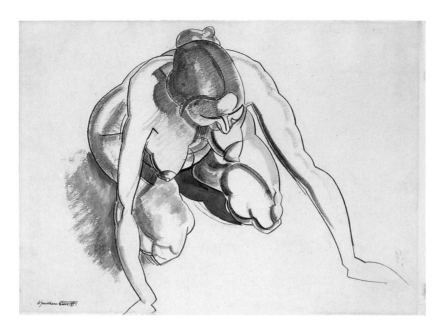

23 Crouching Woman
1919–20
Black chalk, wash
28 × 38 (11 × 15)
Tate

stage he had a commitment for a one-man show from the major Parisian dealer in avant-garde art, Léonce Rosenberg, and was in regular contact with Herwarth Walden's celebrated Der Sturm gallery in Berlin. While he was also aware of the neo-classical 'return to order' of some other artists, particularly in France and Italy, he was suspicious of its general direction: 'We want to construct hardily and profoundly without a hard-dying autocratic convention to dog us and interfere with our proceedings. But we want *one* mode, for there *is* only one mode for any one time, and all the other modes are for other times.'[2]

One direction Lewis took was to refine his enormous talent as a draughtsman until he had acquired an almost uncanny fluency and invention with line. His unpublished 1930s essay, 'The Role of Line in Art', shows how important the concept of line was to Lewis, defining an idea of mastery and insight. His nudes and portraits of the early 1920s work both as representation and as formal construction, series of arcs and occasional near-straight lines defining figures which have weight and strength, humanity and grace. Where Lewis seems to stress the awkwardness of a body, its imperfection and even grossness, he nevertheless finds unexpected beauty and sensitivity. With minimum shading and light washes he creates images from often difficult poses which seem to float in complex elegance against the numinous background of the bare sheet of paper. He has lost none of his love of the subtleties of oriental art, while the economical sharpness of the line confirms a modern vision which admits the threateningly mechanical in contemporary life. Similarly, in his portrait drawings of this period, whether it be the charming *L'Ingénue* (fig.24) or the 'hollow hatchet' head of James Joyce (fig.25) – with whom he had a turbulent intellectual and, on one famous occasion, drunken relationship – Lewis's control of line evokes volume and personality with extraordinary power and finesse.

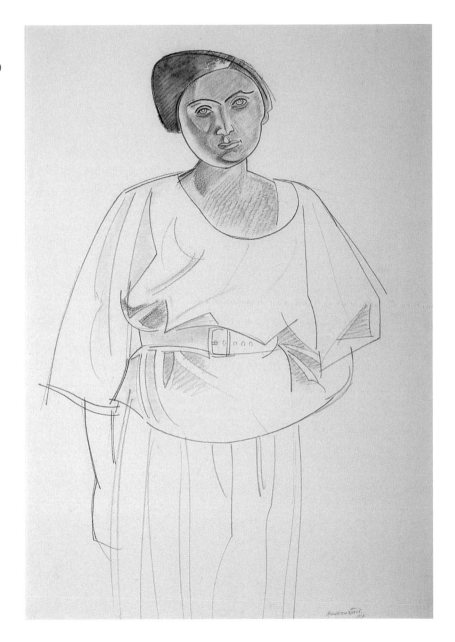

'The Life of a Tyro'

In 1921, coinciding with a linked exhibition at the Leicester Galleries, Lewis published the first issue of *The Tyro*, a journal which introduced the public to a new race of beings, the Tyros, or novices, who represented a new post-war generation of Britons in the age of flappers and jazz clubs. His purpose, rather than escaping into good taste and safe privacy, was to engage with the bracing vulgarity of his times through a satirical assault on its beliefs and manners.

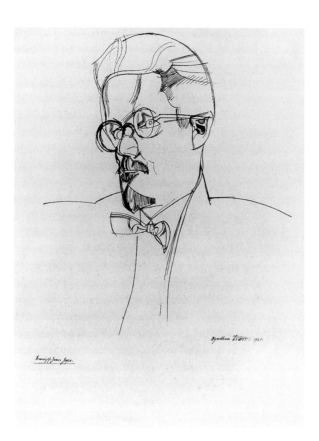

25 Drawing of
James Joyce 1921
Pen and ink
45.5 × 31.5
(17⅞ × 12⅜)
National Gallery of
Ireland, Dublin

These immense novices brandish their appetites in their faces, lay bare
their teeth in a valedictory, inviting, or merely substantial laugh. A
laugh, like a sneeze, exposes the nature of the individual with an
unexpectedness that is perhaps a little unreal ... These partly religious
explosions of laughing Elementals are at once satires, pictures and
stories. The action of a Tyro is necessarily very restricted; about that of a
puppet worked with deft fingers, with a screaming voice underneath ...[3]

Lewis actually signed a contract to write 'the life of a Tyro', which never
appeared. The surviving typescripts and manuscripts for this project describe
another world, the planet O, set in the distant future but inhabited by Tyros
who arrived there by spaceship in 1921 and whose keynote trait is 'vacuity'.
The dramatic combination of the alien and familiar is the kind of imaginative
device Lewis had been working with since before the war and was intended to
create an alternative space for reflection on the present. It was a daring and
bizarre vision and largely misunderstood, or ignored, by his most influential
contemporaries, as he sought to create a 'new type of human animal like
Harlequin'.[4]

 In inventing the Tyros, Lewis is clearly drawing on, and radically updating,
his then unfashionable admiration for Hogarth's moral 'Progresses' and Gill-
ray's fierce satires, with a comic-book brutality of black-and-white caricature
and a sense of design. He was dubbed 'Dean Swift with a brush' and obvious-

ly relished the notoriety of initiating a revival of a lost British satirical tradition in art and literature. The interviews Lewis gave to deliberately chosen middlebrow and popular newspapers at the time proclaim a defiant stance against the lethargy and snobbery he was increasingly frustrated by, whether at Burlington House or in Gordon Square. 'Art today needs waking up,' he told the *Daily Express*. 'I am sick of these so-called modern artists amiably browsing about and playing at art for art's sake. What I want is to bring art back into touch with life ...'.[5]

The Tyro phase produced some of Lewis's most startling oil paintings, some of which he later objected to as too 'posterish'. *A Reading of Ovid (Tyros)* 1921 (fig.26), a painting with which Lewis, unusually, was satisfied on completion, shows two Tyros reading from Ovid, clearly enjoying a salacious passage from the great Roman author. The left-hand figure turns to leer straight out at us while the other, absorbed in his titillation, is nevertheless aware of being watched and strengthens the viewer's feeling of blushing complicity. This narrative, along with baroque and often grotesque forms and a powerful colour scheme, gives the work an almost hypnotic and threatening effect. The satire on neo-classicism is unmistakable, the meeting of Ovid and the brash children of the new age creating an absurd chasm between tradition and contemporary reality.

The ubiquitous Tyro grin was not merely a matter of aesthetic shock tactics. Lewis saw the grin as an expression of a deep infantilism encouraged by a post-war political system which was equally in a state of shock. Lewis speculated whether the stoic smile typified by that of the British 'Tommy', 'might not have resulted in a <u>permanent </u>distention of the muscles, a window dressing of joviality that afterwards <u>could </u>not be abandoned if it <u>would</u>[?]'.[6] Like some premonition of Batman's Joker, Lewis's Tyros are unable to rid themselves of their trauma-induced fixed expression.

Neither is Lewis: aware of his own fragile and questionable position in this world of exploded order, he becomes 'the satirist satirised' in *Mr Wyndham Lewis as a Tyro* 1920–1 (fig.27). There is no escape from the times, even for the artist claiming detachment, and Lewis shows himself as a fierce but implicated being trapped in the lurid glare of the fairground or cinematic world of 1920s Britain.

Lewis also painted some major portraits in oil at this time. His monumental and unearthly *Praxitella* 1920–1 (fig.28), an image of an unfortunate mistress, Iris Barry (or 'Iris Crump' as she put when registering her and Lewis's second child), again makes play of a classical precedent, in this instance the reference being to the celebrated Greek sculptor Praxiteles. A metallic totem, the sitter's head balances like a disconnected portrait bust on a seated body of flattened hollow arabesques. Lewis was a 'classicist' in this period in the sense that he was striving for a cold, hieratic art which stopped 'normal' response, but was equally determined that this urge did not lapse into a comfortable academicism or lazy seeking after grandeur. The 'life' and 'personality' here is all on the surface, the mysterious interior only hinted at by insect-like yellowish eyes. As with the celebrated portrait of Edith Sitwell (fig.29), begun in late 1921 but not completed until the mid-1930s, Lewis was making a kind of

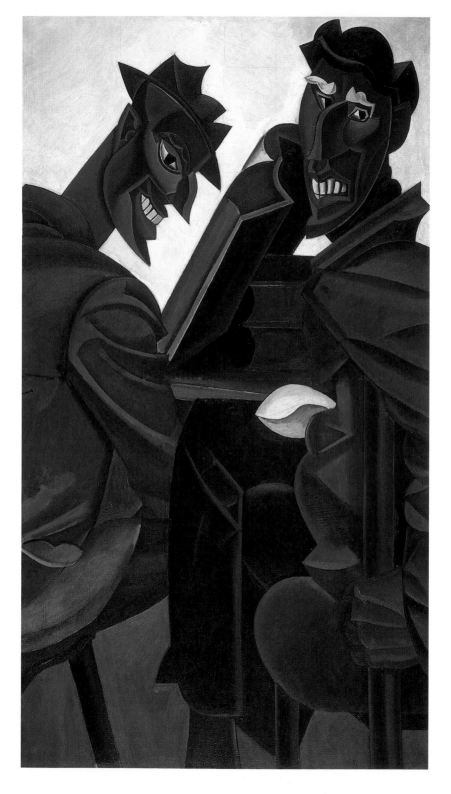

26 *A Reading of Ovid*
(Tyros) 1921
Oil on canvas
165 × 89 (65 × 35)
Scottish Gallery of
Modern Art,
Edinburgh

portraiture which was unlikely to please the sitter and certainly intended to disturb viewers at large. In this he succeeded: Virginia Woolf admitted in a letter that her sister Vanessa Bell the painter and Roger Fry read *The Tyro* in shops 'and won't buy him – which ... proves that they fear him'.[7]

'Contradictions of Matter and Mind'

In *The Tyro* Lewis wrote some important art theory and criticism which reveals how far he now was from most of his contemporaries intellectually and artistically. Had he been more willing to compromise and been possessed of a less difficult and even alarming personality, he might have become the genuine leader of a new avant-garde in Britain. In 'Essay on the Objective of Plastic Art in Our Time', published in the second and final issue of the journal, Lewis denied the possibility of an art removed from the current of life and rebuked the view that what he regarded as the feeble imitation of past forms

27 Mr Wyndham Lewis as a Tyro
1920–1
Oil on canvas
73.5 × 44
(29 × 17⅜)
Ferens Art Gallery,
Hull City Museums
and Art Galleries

28 Praxitella 1920–1
Oil on canvas
142 × 101.5
(55⅞ × 40)
Leeds Museums and
Galleries (City Art
Gallery)

45

in much contemporary art was all that was possible. His own 'classicism' certainly allowed for the inviolable power of great art of whatever period, but he shunned dilettantism and recommended that art be viewed as a very serious game in which human ingenuity and sensibility are stretched as far as they are able to be:

29 *Edith Sitwell*
1923–36
Oil on canvas
86.5 × 112
(34 × 44⅛)
Tate

> The art impulse rests upon a conviction that the state of limitation of the human being is more desirable than the state of the automaton; or a feeling of the gain and significance residing in this human fallibility for us. To feel that our consciousness is bound up with this non-mechanical phenomenon of life; that, although helpless in the face of the material world, we are in some way superior to and independent of it ... In art we are in some sense playing at what we designate as matter ... We are placing ourselves somewhere behind the contradictions of matter and mind, where such an identity ... may more primitively exist.[8]

For Lewis, then, the artist performs a role of great social, if abstruse, value, and in showing us the world, 'only a realler one than you would see, unaided, the delicate point in his task is to keep as near to you as possible, at the same time getting as far away as our faculties will stretch'.[9] This idea of a fine balancing act, a making strange of the familiar by occupying unexpected terrain

46

between spheres of understanding and perception, is quite apparent in his figurative Tyro works and perhaps even more so in the unusual semi-abstract pieces he made at the same time. These return us to some of the approaches of his denser Vorticist works, but are very different in their visual character.

A transitional watercolour drawing, *Room No.59* 1921–2 (fig.30), is instructive in understanding Lewis's motives, not least because of his own commentary on it written about ten years later. The image is of some masked figures confronting one another in a warping stage-like space with a red door numbered '59' in the background. The setting is otherworldly, indeed surrealistic, and the narrative, in so far as there is one, highly mysterious. Lewis's description, however, suggests a means of interpretation:

> Masked figures twirl like waterspouts to the right of a broad bay
> flanked by the severe cliff sides of a serpentine corridor. In the
> foreground an astonished trinity of fugitives is fixed by the grotesque
> gin-fed eye of a kommissar-concierge. This dark rampart of falstaffian
> beef assuages the hunger of the yawning hollow opposite. But it
> stands stolid as a basalt colossus, and from behind its back a buttress
> rears dizzily, with the motion of a top-heavy rocket, to stabilise the
> ramshackle roof through which light leaks as in a dream.
> The figures are cut out of thick iron sheet, bent into graceful folds. The
> hindmost one is a steep pillar. Embedded in its skirt is the contour of a
> severed double-bass. The theme enunciated by this subtle arabesque
> sets up a static three-dimensional fugue. The eye, racing round this
> nightmare interior, grows exhilarated, and returns to ride these
> muscular shapes like mettlesome steeds.[10]

Apart from the distinct intimations of Giorgio de Chirico's works and an allusion to Hogarth's 'serpentine line', a notable feature of this description is that Lewis is writing it as if he doesn't know the content either, as if it came in a dream and is now only accessible by a psycho-analytic procedure of free association. He invokes waterspouts, a bay, a trinity of fugitives, a concierge, Falstaffian beef, a rocket and double-bass, among other images, in describing what he calls a 'three-dimensional fugue'. The aim is to free the engaged mind into a train of words and images which have no limit, even within a 'nightmare interior'. Lewis's art is often about constraint, in space and body, and the mind's capacity for a sort of virtuoso flight from limits.

The intriguingly titled *One of the Backs* 1922 (fig.31) presents a more sinister, but also ridiculous, confrontation of hollow quasi-human forms. On the left a headless figure exposes its naked back to the gun barrel-like phallus protruding from the large multi-faceted armoured presence on the right. The latter has a domed helmet while the former, apparently helplessly, stands by its own helmet which rests on the ground. There is something of Japanese Noh drama about the image, with a science-fiction twist, as an ambiguous sexual ritual seems to be performed in an alien landscape. The fine, sinuous line Lewis had created for himself in the life drawing of the immediate post-war years is also reminiscent of that of the engineering draughtsman and of the natural-history illustrator. Intimations of insect forms, meticulously shaded and

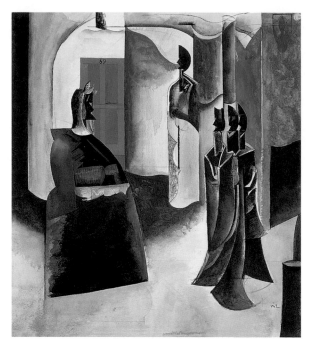

30 *Room No.59*
1921–2
Pencil, pen and ink,
watercolour,
gouache
35 × 31 (13¾ × 12¼)
Private Collection

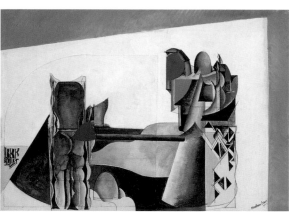

31 *One of the Backs*
1922
Pencil, pen and ink,
watercolour, gouache
with papier collé
33 × 45.7 (13 × 18)
Private Collection

coloured, are probably a consequence of his study of entomological books such as Sir John Lubbock's *Ants, Bees and Wasps* (1885) and the famous works of Jean-Henri Fabre. Scientific history and philosophy were of continuing fascination to the aspiring polymath Lewis as he sought to up the stakes in his search for a new level of aesthetic 'play'.

Archimedes Reconnoitring the Fleet 1922 (fig.32) is one of his finest inventions of the early 1920s, intricately constructed, beautifully coloured like a medieval manuscript and carrying an intriguing historical and conceptual narrative. Archimedes, the aristocratic mathematical genius who, according to Lewis's probable source, Plutarch, defended King Hiero's beautiful city Syracuse against the Roman fleet of Marcellus with a number of brilliantly conceived weapons, is presumably one of the hieroglyphic foreground shapes. Sea and hills, sky and rigging are glimpsed beyond. Archimedes's weapons

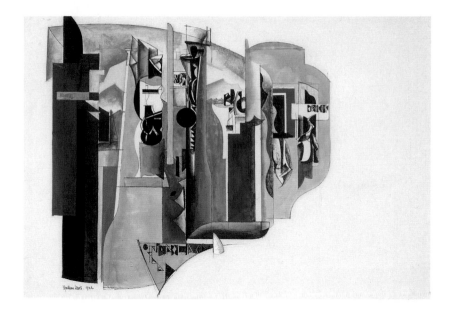

32 *Archimedes
Reconnoitring the
Fleet* 1922
Pencil, pen and ink,
watercolour,
gouache
33 × 47.5
(13 × 18¾)
Private Collection

included the heavy artillery of fireball-hurling catapults, huge rock-dropping poles and ship-lifting grappling hooks, which seem to be among the forms Lewis presents. Famously, he also devised a huge mirrored shield which the Carthaginians used to reflect the sun's rays onto the Roman sails and set them alight. His brilliance was ineffectual in the end and, through a mixture of intellectual pride and absent-mindedness, he was killed by a Roman soldier. Lewis's mathematician's line and complex formal inventiveness, drawn from conic sections and other geometrical sources, are a kind of homage to his unworldly hero, 'the geometrical, hundred-armed giant' as Marcellus called his adversary.

'Man of the World'

Lewis didn't exhibit these works when they were new and they remain, sadly, a lost but highly significant chapter in the history of British modernism. By 1923 Lewis realised he had different work to do and entered an 'underground' period of intense, self-consciously 'heroic', study and writing during which his art took a back seat. It is not possible to fully cover this textual output in an introductory book, but it is important to note its general ambition and to indicate those aspects which bear on Lewis's art.

Frustrated by what he saw as the mediocrity and complacency of much contemporary art, bored with, and often contemptuous of, many of his friends and acquaintances, and dissatisfied to some degree with his own work, he set out to analyse at a deeper level, and across a broader field of inquiry, the conditions for art in his time. As was obvious in the critical reviews of modern art in *Blast* and *The Tyro*, Lewis conceived his work in the context of the various tendencies in modern art, seeing himself as part of a complex historical discourse. Art was always in part, for Lewis, an intelligent dialogue with current possibilities, rather than simply an introspective expression of personal

49

conviction. As he considered the circumstances in which he found himself he realised that political and philosophical questions needed to be addressed before he could feel confident about new directions. His intuition and creativity, therefore, demanded a map.

The bulk of this map was created in a concentrated period of activity between late 1922, the year of his friend T.S. Eliot's *The Waste Land*, and spring 1925, when Lewis handed in a huge three hundred and fifty thousand word typescript with the title 'The Man of the World' to the publisher Alec Waugh at Chapman and Hall. As he told Eliot, he had 'quarrelled with almost everybody in order to get the money and time to write'.[11]

Over the next few years the massive text, suitably enlarged and edited, was published in chunks as separate books and also in Lewis's new journal *The Enemy* (1927–9). These included *The Art of Being Ruled* (1926), *Time and Western Man* (1927) (fig.33), *The Lion and the Fox: The Role of the Hero in the Plays of Shakespeare* (1927) and *Paleface: The Philosophy of the 'Melting Pot'* (1929). Lewis had also published by 1930 a revised version of his early short stories, *The Wild Body* (1927), the first part of a metaphysical trilogy *The Childermass* (1928), and a notorious satire on the London arts scene, *The Apes of God* (1930), which transformed his Tyros into recognisable and, in the event, highly aggrieved figures in the real world. The whole range of publications is breathtaking in its scope and scale and, even though its quality is uneven, it amounts to one of the great achievements in English thought and literature in the twentieth century. Its central subject is art and the artist and its unremarkable but, for Lewis, fatal conclusion that 'to get some sort of peace to enable us to work, we should seek the most powerful and stable authority that can be devised'.[12]

Lewis did not want a return to former political modes and cultural styles; indeed, he thought revolution and change were inevitable in the West, driven as it was by the science and technology which had distinguished it for four hundred years. He saw the 'democratic educationalist state' as a trap, however, which would only produce passive obedience and, by the deceit of giving 'the public what it wants', benefit politicians and the capitalist class alone. He was not, as is often thought, unduly enthusiastic about the 'great man' he thought would be best for the future, believing that the 'hero' of the European imagination was usually productive of only war and destruction; with ambivalence, and inspired by the thinking of the utopian political philosopher Charles Fourier, he suggested an unusual socialist state based on natural caste rather than social class, led by a dictator who '*would be made to pay for ruling in every way*'.[13] He certainly had no interest whatsoever in the classicising nostalgia supported by Stalin and Hitler in their cultural policy; he remained

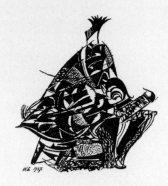

TIME AND
WESTERN MAN
BY
WYNDHAM LEWIS

CHATTO AND WINDUS
LONDON
1927

33 Title-page from
Time and Western Man 1927
Tate Archive

a defiant exponent of the artist's autonomy and of modernist invention, even if he rejected formalist abstraction or surrealist automatism. Both 'reaction' and 'revolution' in these forms were, for Lewis, a corruption of the possibilities of a genuinely radical art. This conviction led him to attack friends such as Ezra Pound as 'the Revolutionary Simpleton' and James Joyce, whose *Ulysses* he described as the 'sardonic catafalque of the Victorian world'.[14] The central character in *The Apes of God* is an innocent young poet who completely fails to realise the significance of the General Strike as it takes place around him.

In art, Picasso, whom it has been often unwise to criticise in conventional circles, was a brilliant talent, Lewis believed, whose 1920s classical figures were 'beautifully executed, imposing human *doll*(s)'; by contrast Michelangelo, who Lewis would not recommend be copied except in spirit, had, in the Sistine Ceiling, created figures of 'an infectious life ... Between the outstretched forefinger of Adam and the finger of the hurrying Jehovah, there is an electric force in suspense of a magnitude that no vegetative imbecility, however well done or however colossal ... would be able to convey.'[15]

A further dimension to Lewis's critique of contemporary culture is his observation that post-war Europe was regressing to a wished-for state of childishness which, for some of the wealthy, had become a desire to become bogus artists. They alone were able to act out, though only feebly in caricature, the Marxian fantasy of a creative utopia, thus irresponsibly ignoring their true role as patrons. Meanwhile, the professional artist was unable to rent a decent studio, nor had he a recognised authority within a political elite.

Lewis's most conspiratorial view, however, was that the West was dominated by a 'time philosophy' inaugurated by his erstwhile inspiration Henri Bergson, to be found in everything from the media and advertising to academic theory, the new 'science' of behaviourism, political ideology and fashionable modernism. The obsession with the 'Flux' expressed an urge, derived from the dominant scientific world-view Lewis in many respects applauded, to dissolve the traditional 'trinity' of God, Subject and Object into an endless stream of 'becoming', where art and morality become relative only to evolutionary forces beyond their control. These forces are those of the 'natural world', a sphere Lewis was always extremely sceptical about even while he insisted we had no choice but to live in it. Whether it be Impressionist painting or Gertrude Stein's and Virginia Woolf's stream of consciousness, 'naturalism' demanded too great a submission of the creative will to produce an art which transcended the world in the way Lewis instinctively required. Where some saw human liberation and expression, Lewis saw a self-deluding loss of power and thus a denigration of human individuality; as he said about the ideas of the philosopher of science A.N. Whitehead: 'you are no longer a centralised self, but a spun-out, strung-along series, a pattern-of-a-self, depending like the musical composition upon time'.[16] 'Nature' could not satisfy the ultimately religious and metaphysical impulse Lewis was coming to understand as lying at the heart of his vision in which God seems to be a remote artist, not an immanent moralist. He claimed to stand for 'space' against 'time', for the visual rather than the musical.

This partly explains why Lewis, in aesthetics, regarded 'deadness', as he had already explained in *Tarr* in 1918, as a prerequisite of the highest artistic attainment, and also his fascination with the writings of Sir Grafton Elliott Smith on Egyptian art and mummification and his ridicule of the popular academic works of the Cambridge classicist Jane Harrison in her enthusiasms for ancient Dionysiac ritual. As we have seen often enough, in Lewis's account art and religion proceed from a separation of the individual from the crowd, and the painter, in his dedication to the workings of the intelligent eye, embodies the virtues of that separation. The Egyptian creation of hieratic idols and statues as images of the soul was a creation of a powerful 'deadness' which expressed the life of true spirit. In between writing and editing all these interweaving thoughts into digestible, and sometimes indigestible, portions, Lewis began to make images of this creative condition fitfully crystallising in his mind.

'Supernatural Power'

Lewis wrote in *Time and Western Man*: 'If you say that creative art is a spell, a talisman, an incantation – that it is magic, in short, there too, I believe you would be correctly describing it. That the artist uses and manipulates a supernatural power seems very likely.'[17]

Lewis's intermittent but often quite brilliant visual output from 1926 to 1930, mainly in drawing and watercolour, is characterised by a curiously disjointed integrity of talismanic form. When Lewis wrote in June 1925, to Olivia Shakespear, the occultist muse of Yeats, that between writing tasks he was working on a sequence of drawings for her that had 'some definite object' in mind and that he would explain them to her, there was the suggestion of some special significance to them.[18] One of them illustrated (fig. 34) here gives some idea of their collective power, endlessly fascinating the eye and productively if inconclusively irritating the associative faculties. The phallic totem form certainly reflects a known interest of Lewis's in North American Indian art and confirms his continuing use of non-European sources; Lewis is also suggesting a male principle of creativity. Yet there is also the luminous quality of the medieval manuscript and the delicate factuality of a natural-science illustrator. Lewis has certainly been looking at Surrealist art, in particular the automatic drawing of André Masson and the paintings and collages of Max Ernst. Unlike that art, however, this work has a tightly controlled verticality, sharply defined against the paper support. Within the archaeologically suggestive composition one can see, among other fragments, masks, architectural detail, body parts and, at the top, a torso from which an emanation seems to be floating free. Bubble- and flame-like shapes help to reinforce the suggestion of some sensuously upward movement produced as if by chemical, perhaps alchemical, reaction within a glass vessel which itself takes on the form of the resulting product. It seems lame to propose the obvious point that this is an image about its own creation, but this seems to be at least a significant aspect of the work's otherwise hidden meaning. Things metamorphose into other things and a precarious order is maintained by a shaping formal discipline.

Olivia Shakespear's spiritual interests would no doubt have been satisfied by the suggestion of some astral body which finally escapes the process into an immaterial sphere. The sheath-like hollow shapes which are much in evidence may allude to Hindu ideas of the three 'husks' which surround the immortal soul (the atman) that Lewis had been interested in for some years. A significant passage in his satirical novel *The Apes of God* (1930) has the naïve initiate to the art world, Dan Boleyn, instructed in the yoga disciplines, or asanas, necessary to artistic creativity, by the predatory Horace Zagreus. His object of

34 *Abstract Composition* 1926 (detail)
Pen and ink, watercolour, wash, pencil
56 × 26.5
(22 × 10⅜)
Collection of Mr and Mrs Herbert Lucas

attention is the crowd at a Lenten party held by Lord Osmund, modelled on Osbert Sitwell: 'Yoga! Indian stuff. Will All this company is but one unit. It is one thing, a unit. You have to compress it for it to be a single body – you define it, set terms to it, endow it with a hide to tie it up, force it into one envelope. Cram it in – it will go nicely. But yourself, you hold yourself outside it. That is quite good yoga.'[19] Although it is an ironic episode, as Zagreus is a fraud, the 'eastern wisdom' invoked is credited to the mysterious 'Pierpoint', a character who represents to an important degree the absent Lewis's esoteric views.

Lewis's fascination with underground hero cults, cave and chthonic deities, the immortality of the soul, blessed isles, the disintegration of the personality and other related arcane matter, all seem to bear on the works of this period when he was probably reading, or re-reading, Nietzsche's friend Erwin Rohde's *Psyche: the Cult of Souls and Belief of in Immortality among the Greeks* (1896). *Figures in the Air* (fig. 35) was reproduced in the first issue of *The Enemy* and shows his debt to Giorgio de Chirico's 'Metaphysical Painting', an example of which was also reproduced. The horizontal figure is one of the first examples of a recurring motif in Lewis's subsequent work, representing a 'hero' drawn from Lewis's interest in ancient cultures, in this case probably the visionary Celtic one he identified with. The figure's physical condition is ambiguous – is he dead, half-dead, asleep or dreaming? The floating figures which seem supported on a pole rising from behind him may be his progeny or other selves, it isn't clear, and the setting is stage-like and suggestive of the modern metropolis. Lewis travelled to New York in 1927 and one of his drawings, which also has a prominent buried figure with others emerging into a skyscraper landscape, reflects the strange excitement of this first trip.

Below left
35 *Figures in the Air*
1927
Pencil, pen and ink, watercolour, gouache with papier collé
29.2 × 16.5
(11½ × 6½)
Private Collection

Below right
36 *Creation Myth*
1927
Pen and ink, gouache, newspaper and papier collé
32.5 × 29.5
(12⅞ × 11⅝)
Tate

37 *Bagdad* 1927
Oil on plywood
183 × 79 (72 × 31⅛)
Tate

Creation Myth (fig. 36) works the same quarry of ideas but extends it into a
watery prehistoric setting. Arcing shapes sweep down the collaged composi-
tion, defining fish forms in a fractured world of sea, sky and mountains. At the
bottom of the picture a couple seem to copulate as if their union creates
the world they inhabit; Lewis saw the artistic mind as bisexual and the two

figures thus probably represent the artist. He also described the artist in *The Caliph's Design* as being 'older than the fish',[20] indicating his belief in the unfathomable originary powers he possesses. In the bottom left-hand corner of the work another figure, like a crouching mannequin, may be the contemplative figure of the artist from whom the whole image expands through an occult 'separation of powers'. Lewis was making an outright, and even outrageous, defence of the artist's elite position for, as he said in his 1925 essay 'The Politics of Artistic Expression': 'In a well-ordered state there must be artists to prevent the majority from taking to being artists.'[21]

The culminating work of this sequence of 'creation myths', or 'fragments I amuse myself with',[22] as he nonchalantly claimed, is the emphatically vertical and dream-like panel *Baghdad* 1927 (fig.37), which was painted in oil on a cupboard door, presumably for Lewis's own Bayswater home. The reference to the great city recalls, of course, Lewis's 1919 tract *The Caliph's Design*, although eight years later it carries a very different, more elegiac significance, perhaps in part responding to Oswald Spengler's *The Decline of the West*, a book he had actually attacked for its fatalistic pessimism. The image is crowded with architectural forms such as tall blocks and spiral staircases, hanging gardens and two large heads which may be the terms of fertility divinities. In an essay of February 1929 called 'A World Art and Tradition', Lewis referred to a minority of artists such as himself, scattered across Europe and in New York, who represented a 'submerged civilisation', the 'buried heroes' of a future unable to come into being in an age of commerce and aesthetic compromise. Lewis was no collectivist but he saw art as an aesthetic 'Left', as a last bastion of intelligence and invention in a world where most artists were reduced to product design and advertising – or to the Roger Fry-endorsed 'ugly and untidy kitchen-garden that is a London Group exhibition'. Artists such as Max Ernst, Paul Klee, Yves Tanguy and Paul Nash are, for Lewis, like 'Atlantans' who have created a 'complete world, with its aqueducts, its drains, its courts, private dwellings, personal ornaments, almost its religion with its theurgic implements, which have never existed'. Perhaps most significantly, Lewis suggests that the new art is the result of something most people have not yet noticed: 'the Earth has become *one* place, instead of a romantic tribal patchwork of places'.[23] This internationalism should produce a 'world-art' which expresses a 'strange synthesis of cultures and times'. In *Paleface*, written the same year, Lewis had attacked the sentimental and patronising negrophilia and exoticism of writers such as D.H. Lawrence and proposed instead a racial 'melting pot' as an ideal which would lead ultimately to a new culture, drawing on 'Western' pragmatism and dynamism and 'Eastern' spiritual and aesthetic sophistication.

7

'LONELY OLD VOLCANO'
THE 1930s

The soul of the philosopher goes to dwell with 'that which resembles
it, the invisible divine, immortal and wise'; in a place 'excellent, pure
and invisible'. The unjust, and the only popularly 'good', are, in
Socrates' ethical Zoo, allotted their respective shapes. Asses, wolves,
hawks and kites are inhabited by souls that have shown their
aptitude for such destinies as these imply.[1]

Lewis became notorious as a result of two books published in 1930 and 1931.
The first was his huge satire on the deep cultural decay underlying the London
arts scene, focused deliberately on its 'surfaces', *The Apes of God*. The second
was *Hitler*, an account of his experiences and thoughts on a trip to Germany
in November 1930. This latter book in particular was a huge mistake of judge-
ment, politically and in terms of his career, and behind its error may lie Lewis's
view, expressed in *The Art of Being Ruled*, that 'the ethical canon must ulti-
mately take its authority from taste'. Lewis became, quite understandably,
obsessed with the likelihood of another world war and throughout the 1930s
was an 'appeaser', claiming until a few years later that Hitler was 'a man of
peace' whose anti-Semitism was just rhetoric. He also wrote a number of fair-
ly ill-advised books, such as *Left Wings Over Europe* (1936) and *Count Your Dead:
They are Alive!* (1937) (fig.49), which were anti-war interventions into imme-
diate international political debates and which, as he later realised, were naïve
and damaging. His article for Oswald Mosley's *British Union Quarterly* in 1937,
supporting the 'small trader against the chain-store', simply confirmed for
many that Lewis was what an admirer, W.H. Auden, dubbed the 'lonely old
volcano of the right'. As ever, Lewis's views at this stage are actually often
difficult to pin down, his art and other writing giving the best view on his
complex mind and shifting opinions.

The 1930s were another remarkably active decade for Lewis. In spite of ser-
ious, at one point near-fatal, illness which lasted for long periods, he wrote,
apart from his political books and articles, three novels, four major books of
literary and cultural criticism, a new illustrated edition in 1932 of *Enemy of
the Stars* and a travel book, *Filibusters in Barbary* (1932), based on a few
months' experience in Morocco with his young wife, the artists' model Gladys,
or 'Froanna', Hoskins. Unsurprisingly, three of these books prompted legal
action by others. Lewis also wrote his first autobiography in 1937 and edited a
collection of his writings on art in 1939, shortly before leaving Britain for
North America. He also produced a magnificent portfolio of portrait drawings
of celebrities in 1932 (fig.38), charming illustrations for Naomi Mitchison's
fantasy narrative *Beyond This Limit* (1935) (fig.39) and in 1937 held a major

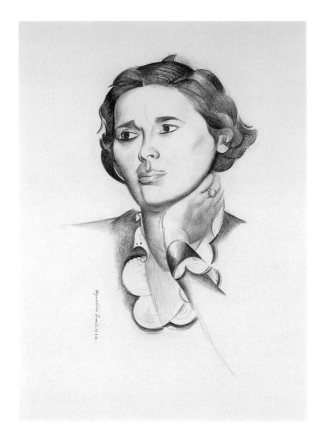

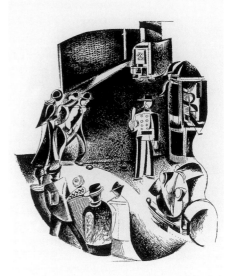

38 *Rebecca West*
1932
Black chalk
33 × 25 (13 × 9⅞)
National Portrait
Gallery, London

39 Image from
Naomi Mitchison,
Beyond This Limit
1935
Tate Archive

exhibition of oil paintings and drawings. In spite of his controversial views and behaviour, Lewis was an object of much fascination and admiration among even leftist young artists, writers and intellectuals for his brave individualism and his undaunted and undoubted genius. His youthful admirers included Geoffrey Grigson, Julian Symons and Henry Moore, all of whom, like older supporters such as Walter Sickert and Augustus John, were hostile to the Fascism they assumed Lewis fully supported.

'Some Sort of Series'

During the 1920s, as we have seen, Lewis had intermittently but to great effect produced a body of visual work which in its creation of a new vocabulary of form and themes now laid the foundations for a more concerted effort. In 1933 he began work on a series of twenty-four oils and thirty drawings and watercolours which, after delays caused by illness, writing and futile attempts to avert the coming world war, were exhibited at the Leicester Galleries in December 1937. Many of these works were concerned with historical subjects and may have been partly a one-man attempt to respond to what Lewis would have seen as the nationalistically sentimental series commissioned by the House of Commons in the mid-1920s from academic artists such as Glyn Philpot. They constitute a form of 'secret history'.

Lewis said the oils were 'in some sort of series',[2] though it is hard to organise them in a clear order. There is, however, a group of recurring themes concerned with culture, the past and the afterlife which can be linked convincingly and bear witness to an imaginative project of great depth and subtlety. Some of the works are 'personal' in that they are concerned with the experience of ill-health and thus the limits imposed by our physical being; *The Convalescent* (fig.40), however, probably alludes as much to Nietzsche's writing on the subject as to Lewis's own lengthy stays in nursing homes. Here is a resting and more human rather than buried and epic hero, supported by a loving partner in a peacefully shady room with a hallucinatorily prominent tea service in the foreground. Lewis was now seeking a new form of figuration and experimenting with a more eclectic style. This work might be the opening image, a waiting-room so to speak, for the suggested series which becomes progressively more unearthly in subject and atmosphere.

Inferno (fig.41), apparently the last painting in the 'series' Lewis completed, suggests a literal descent into hell, where the inverted 'T' composition, in Lewis's words, presents a 'world of shapes locked in eternal conflict ... superimposed upon a world of shapes, prone in the relaxations of an uneasy sensuality which is also eternal'.[3] The painting contrasts fiery Michelangelesque figures with perhaps more Blakean ones bearing Tyronic grimacing features hauntingly suggestive at once of the concentration camp and the crowded beach.

Beyond this fall into infernal regions lie other worlds in Lewis's imagination which seem to occupy the borderlands just outside Heaven, between the physical and metaphysical, which he had described in his philosophical fiction *The*

Below
40 *The Convalescent*
1933
Oil on canvas
61 × 76.5
(24 × 30⅛)
City and County of
Swansea: Glyn
Vivian Art Gallery
Collection

41 *Inferno* 1937
Oil on canvas
152.5 × 101.8
(60 × 40⅛)
National Gallery of
Victoria, Melbourne,
Australia

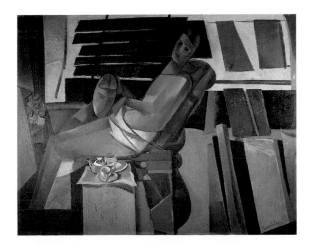

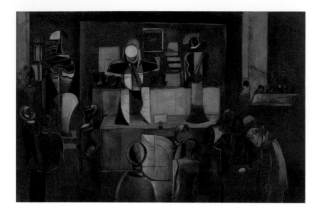

42 *Cubist Museum*
1936
Oil on canvas
51 × 76
(20⅛ × 29⅞)
Collection of Mr and
Mrs Herbert Lucas

Childermass in 1928. *The Childermass*, which contains some of Lewis's most brilliant literary invention, describes an afterlife where, as in contemporary Europe, the passive population is governed by malefic forces hiding behind various forms of 'sham democracy', in which intellectuals and artists, such as the central character Pullman, have cynically allowed themselves to be co-opted. In art that might equally be Russian Social Realists or English Post-Impressionists; in literature it could be Gertrude Stein or James Joyce, the main model for Pullman. Like Blake, Lewis believed the artist should maintain his independence from ideology at all costs if he was to avoid what Julien Benda had called the '*trahison des clercs*' ('treason of the intellectuals'). The paradoxes and contradictions for Lewis are self-evident and he certainly never imagined he was immune to such complexities.

His *Cubist Museum* (fig.42) is one of the more humorously satirical paintings which visualises this interdependence of the individual and culture, the half-bemused viewers subtly becoming like the objects they are observing. Throughout the 1930s Lewis had been writing art and architectural criticism in which he defended modernism and displayed a wide-ranging knowledge of contemporary developments in Europe and America. Here he muses on the audience for this vision, perhaps inspired by Alfred J. Barr's recently opened Museum of Modern Art in New York. Lewis was also warily sympathetic to Surrealist art, which made a major impact in London in 1936 at the New Burlington Galleries.

In the background of *One of the Stations of the Dead* 1933 (fig.43), a Styx-like river with a red sailing vessel seems to hover over a foreground group of flat, empty figures awaiting their uncertain fate at the hands of Lewis's sinister central figure in *The Childermass*,'the Bailiff'. This is a dark world of shifting external form and psychological identity where there is no solid basis for interpretation or judgement, only power and manipulation and the resulting oppression of the masses, or 'peons' as Lewis called them. One of the main characters in the novel embodies the indeterminate and treacherous chaos: the idiotic Satters, who 'in the dirty mirror of the fog sees a hundred images, in the aggregate, sometimes as few as twenty, it depends if his gaze is steadfast. Here and there their surfaces collapse together as his eyes fall upon them, the whole appearance vanishes, the man is gone. But as the pressure withdraws

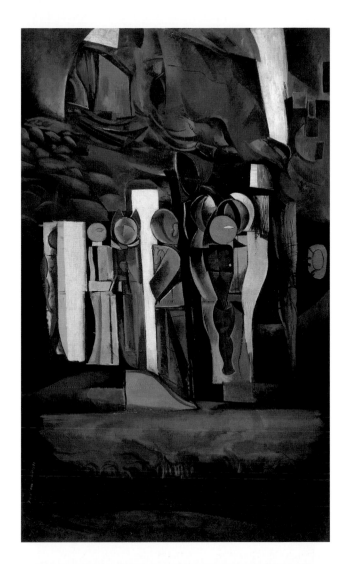

43 *One of the*
Stations of the Dead
1933
Oil on canvas
127 × 77.5
(50 × 30½)
Aberdeen Art
Gallery & Museums

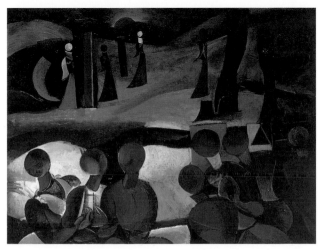

44 *Red Scene* 1933
Oil on canvas
71 × 91.5 (28 × 36)
Tate

of the full-blown human glance the shadow reassembles, in the same dark posture, every way as before, at the same spot – obliquely he is able to observe it coming back jerkily into position.'⁴

This is the uneasy, undulating landscape of another visual report from the afterworld, *Red Scene* 1933 (fig.44), with its ominous setting sun, distant floating angels and faceless peons, or 'monads' as Lewis later called these generic figures. In his preface to the 1937 exhibition, Lewis reminded his audience that 'the art of tragedy is as much the business of the painter as it is the business of the dramatist'.⁵

In his overtly 'historical' paintings Lewis also maintains a puzzling and questioning approach to his chosen themes. *Inca and the Birds* (fig.45) draws on the Romantic narrative of the blind American historian William Prescott's *History of the Conquest of Peru* (1847). Lewis described the painting as 'a (non-Freudian) dream picture'⁶ and the image has a decidedly enigmatic quality with its apparently mirrored foreground Inca on the left, exiting figures on the

45 *Inca and the Birds*
1933
Oil on canvas
68.5 × 56 (27 × 22)
Arts Council
Collection, Hayward
Gallery, London

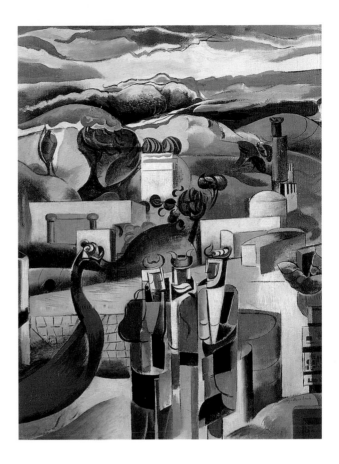

46 *Landscape with Northmen* 1936–7
Oil on canvas
67.5 × 49.5
(26⅝ × 19½)
Private Collection

right, two birds in the middle ground of a desert and a 'mountain-palace', as Lewis described it, suggesting books on a shelf in the distance, beyond what is presumably the legendary Lake Titicaca. In his book, Prescott tells of the arduous journey the Inca prince must undertake in order to find a unique pair of heavenly birds, the 'coraquenque'. His task is to procure a feather from each bird and upon his return his people will be able to recognise him as a true divinely appointed leader. For Lewis, interested in the rise and fall of civilisations, and the chaos of his own transitional world, the meanings of this myth of cultural and political authority were resonant with ironic possibility. The birds are undoubtedly magical creatures and traditionally emblematic of the soul. It also seems likely that the round-faced Inca is a false leader, who has somehow acquired the feathers without undergoing the rigorous training and risky journey required. Certainly Lewis is also intrigued by Prescott's surmise that an Egyptian-inspired civilisation preceded that of the Incas and that the Spanish were able so easily to sweep away such a remarkable civilisation. Lewis also saw a racial link between the Celts, the Berbers of North Africa, the Atlantans of legend and the Incas – underlining how his mythical imagination drew together different times and places in often highly personal ways. As a Welshman, by name at least, Lewis is the *welschere* ('stranger') and descendant of a 'lost race', who is in permanent opposition to the dominant culture.

Invasion of one civilisation by another, perhaps inferior, one was continually fascinating for Lewis as a sign of deep historical forces. *Landscape with Northmen* 1936–7 (fig.46) shows three figures with horned headwear standing by a Viking vessel in the foreground. Behind them is a landscape with buildings which may be Mediterranean, suggesting a moment of intense 'difference' and the likelihood of violent conquest as a northern culture of 'will' overcomes the gentler civilisation of its opposite.

In *The Surrender of Barcelona* (fig.47) Lewis draws on Prescott again, this time from his *History of Ferdinand and Isabella the Catholic* (1838), to create his most impressively architectural painting as he sets out, in his own words, 'to paint a Fourteenth Century scene as I should do it could I be transported there, without too great a change in the time adjustment involved'.[7] The painting is reminiscent in its compositional format of *The Crowd* of 1915, yet here we see how far Lewis has travelled as an artist, from the severity of Vorticism to a richly coloured and intricate surface of detail and incident. The subject is set in 1472, when Ferdinand and Isabella are finally triumphant in the bloody war of succession, entering the city through the Gate of St Anthony and thus opening up Spain's future as a Catholic Imperial power in Europe and the New World. The armoured figures arrayed along the base of the painting lead the eye to its centre, with mounted and foot soldiers breaching the city where fires and executions take place under huge towers and walls. In the distance a view of boats in a bay suggests another world of peace and calm. Lewis is evidently also referring to the Spanish Civil War in the 1930s and Franco's eventual victory, a subject he had dealt with in his novel *The Revenge for Love* (1937). Anti-Communist as he was, and defending a pro-Franco position politically, Lewis, paradoxically, donated a work to a Republican fund-raising art auction.

'Immovable and Unchangeable'

The Leicester Galleries exhibition, though very well-received critically, was not a commercial success. However, in 1938 Lewis at least made the front pages with his portrait of his friend and ally T.S. Eliot (fig.48), which was rejected for inclusion in its Summer Exhibition by the Selection Committee of the Royal Academy. Lewis had certainly anticipated such a response, or at least controversy of some sort, and his only submission to an institution he deplored was clearly intended to raise his profile at the time. He believed the Academy was an annual commercial exhibition rather than, as it might have been, a powerful shaper and arbiter of taste, and thus the very image of Britain's cultural malaise. 'The Royal Academy is immovable and unchangeable – for ours is a Through-the-Looking-Glass country and its landmarks can only be explained in terms of Alice's fancy.'[8]

Friends rallied round to support Lewis, who appeared on a Pathé newsreel and took great pleasure in his newspaper renown, and Augustus John even resigned from the Academy in protest. *The Star* got Lewis to write an amusing piece, choosing fifty works he considered aesthetically bearable at the Academy exhibition and suggesting the remaining space vacated by his fifteen-

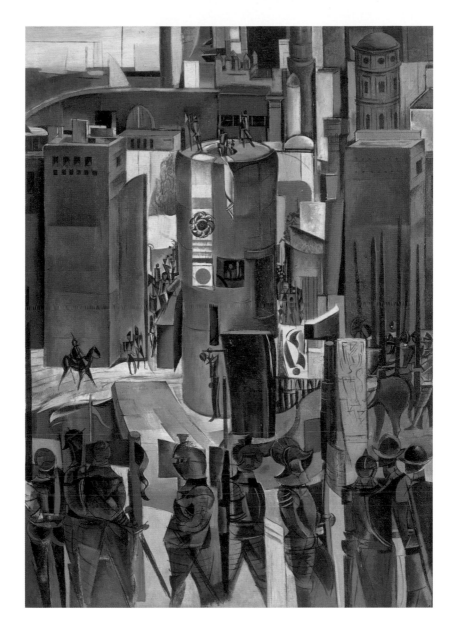

47 *The Surrender of Barcelona* 1936–7
Oil on canvas
84 × 59.5
(33⅛ × 23⅜)
Tate

hundred rejects be turned into dance halls, bars and an ice rink. The 'Picture of the Year', Russell Flint's trite image of the Spanish Civil War, was reproduced by *The Star* and Lewis attacked it as failing to move the spectator to indignation at the '*desastres de la guerra*' because 'of the so much more obvious disaster it records in the mere matter of technical tact'.[9] Winston Churchill, an amateur artist who was entirely opposed to the professional Lewis's appeasement of Hitler, sided with the Academy when giving a speech at Burlington House on the occasion of the exhibition's opening, referring to 'high-mettled palfreys prancing and pawing' and defending the Academy's role of holding 'a middle course between tradition and innovation'.[10]

48 *Portrait of T.S. Eliot* 1938
Oil on canvas
132 × 85 (52 × 33½)
Municipal Art
Gallery, Durban

What of the portrait itself? It is surely one of the great portraits of the twentieth century, and a highly 'academic' one at that, 'burying Euclid deep in the living flesh' as Lewis described the approach of his new mode of 'Super-Naturalism'. It is also a quietly satirical piece, as Eliot would have realised, having suffered at Lewis's critical hands in an essay in *Men Without Art* (1934) for his theory of creative 'impersonality' which Lewis considered had condemned Eliot to 'an unreal position'. Eliot's status as the leading apostle of literary modernism was, in Lewis's opinion, achieved at the expense of meaningful engagement with the world's awkward personal and public realities. He chose to hide in a strange besuited limbo world of the High Church, Bloomsbury and Faber and Faber, and Lewis presents a warily seated man whose powerful theological imagination discreetly wells up in semi-abstraction on either side of the screen behind him. His head's shadow cast on a pale green central panel creates a peculiarly enigmatic vacant impression, perhaps descriptive of what Lewis later referred to as the poet's 'elegant ironic'[11] style. The Eliot portrait also demonstrates Lewis's commitment to an art of the eye and 'the outside' of things for which he had since the 1920s claimed to be a 'fanatic'.

Lewis also painted a remarkable portrait of his old Vorticist ally Ezra Pound

49 Dust jacket for *Count Your Dead: They are Alive!* 1937 Wyndham Lewis Memorial Trust

in 1939 (fig.50). Pound had lived in Italy since the 1920s, writing his long poem the *Cantos* and vigorously supporting Mussolini who he believed, in spite of all evidence to the contrary, was the inspired leader of a dynamic new civilisation. Lewis remembers Pound arriving at his studio for a preliminary drawing, 'coat tails flying, a Malacca cane out of the 'nineties aslant beneath his arm, the lion's head from the Scandinavian North-West thrown back. There was no conversation.' Pound then commanded, 'Go to it Wyndham!' and settled back so comfortably that he dozed off.[12] Where in his Eliot portrait Lewis had matched the sitter's personality with a tight and geometrical style in a vertical format, here Pound's more romantic persona is reflected in a languidly dreamy pose horizontally organised, perhaps echoing Whistler's famous portrait of Carlyle, with closed eyes and a loosened tie and open shirt collar. The paint is loosely worked in the body and much of the background, an unexpected effect for the usually geometrical and precise Lewis. Pound is the quaintly affected and ageing bohemian to Eliot's careful Establishment senior bank official. Behind the same chair as Eliot had sat in, seen in three-quarter view, are a seemingly 'unfolding' still life on a side table and a canvas

50 *Ezra Pound* 1939
Oil on canvas
76 × 102
(29⅞ × 40⅛)
Tate

against the wall with a Whistlerian, or perhaps Turnerian, wash suggesting sea, sky and sunset. This is the historical sphere of Pound's Mediterranean imagination which Lewis had discussed in a devastating critique of Pound's poetry in *Time and Western Man* in 1927. Pound, however, seemed always to accept Lewis's criticism with good grace.

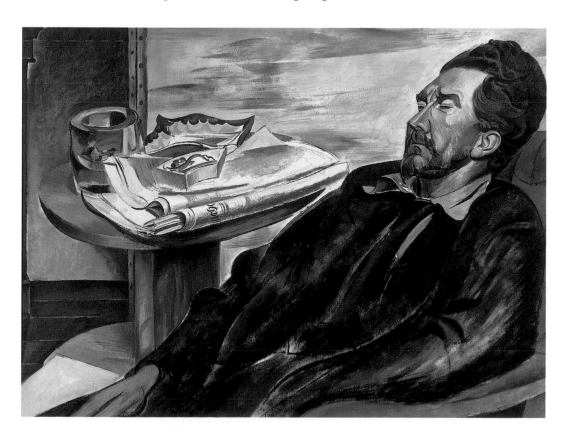

'THE HUMAN AGE' 1940–1957

He saw in front of him something like a large black hole
in the landscape whichever way he turned his head.[1]

Lewis, his wife and their Sealyham terrier left England on 2 September 1939 aboard the *Empress of Britain*, bound for Toronto, Canada by way of Quebec, where they landed on 8 September. Although his political reputation had improved somewhat after the publication of his ironically titled *The Jews: Are They Human?* in March 1939, and his artistic career showed signs of resurgence, particularly as a portraitist, the impending war and financial problems decided him in favour of a clean break with Britain. He hoped to have a New York exhibition of recent work, to write, teach and lecture, and to develop a network of contacts which would allow him to make a living as a portrait painter.

'Self Condemned'

Almost inevitably, Lewis, in spite of his strong Canadian and American connections, managed to make as many enemies as friends during his five years abroad. He was too strange, too sophisticated and too opinionated to survive easily in what were often backwaters such as the State University of New York at Buffalo, where he painted the Chancellor; or Toronto, where he lived in a hotel with his wife for two years and offended the local academics with *America, I Presume* (1940), a book of comical and innuendo-ridden first impressions narrated by a blimpish Englishman, which entirely misjudged his hosts. With a few exceptions Lewis's portraits were unsuccessful either aesthetically or socially, often displeasing the sitter on account of slapdash technique and lack of likeness. While such weaknesses are due in part to the onset of the blindness, caused by a pituitary gland tumour, which was complete ten years later, they also reflect an impatient lack of respect for others and a psychological disturbance which amounted to near-breakdown.

Lewis was more alone than he had ever been and, poor and often ill, was beginning to realise the nature of the errors he had made in his tempestuous career. He even seems to have considered the early psychological origins of his troubled life, as well as more obviously those of the militarism he had opposed throughout the 1930s, in the grotesque dark humour of the watercolour *Mother Love* 1942 (fig.51), which shows 'mummy's little soldier' as a mannequin seated on the monstrous maternal lap. Thematically linked to the searing self-analysis of what is widely regarded to be his greatest novel, *Self Condemned* (1954), the work concerns Lewis's recognition of the human reality of the mother–child relationship, a relationship of masculine and feminine

he had constantly struggled with. Lewis's visual inventiveness and technical skills, however, are undiminished, even in such apparently slight works.

In 1941 and 1942 Lewis had what proved to be virtually a final throw of his dice as an artist of the imagination – in the remote 'sanctimonious icebox' of Toronto. A sequence of visionary watercolours from these years may be viewed as among his finest works and, unexpectedly, markedly in tune with the direction American modernist art was to take over the following decade. Whether Lewis had any contact with the New York avant-garde on his extended trips to the city we cannot be sure. He knew Alfred H. Barr at the Museum of Modern Art (where Iris Barry was in the Film Department), and it may be that he had some familiarity with the expatriate modernist scene which was galvanising younger artists such as Jackson Pollock and Arshile Gorky.

The Mind of the Artist about to Make a Picture (fig.52) is an important transitional image, conceptually if not quite chronologically. It shows the torso of a familiar horizontal sleeping figure lying on some form of banquette or mattress, from under which indeterminately insect-like forms emerge wriggling. Above the figure, whose face is turned downwards towards an open book, a complex of forms rises in front of a curtained window, through which a patch of royal blue sky can be seen. Immediately above the figure's head is a canvas on which the image is repeated and within that a repetition of that which, by implication, suggests a recession ad infinitum, like the image of the Chinese boxes in *Tarr*. Cloud-like shapes and intimations of small solar systems float against the yellow background of a world in which beauty and order are glimpsed momentarily by the soul's fitful movement.

Below left
51 *Mother Love* 1942
Pen and ink, pencil, watercolour, wash
43.6 × 28
(17⅛ × 11)
Private Collection

Below right
52 *The Mind of the Artist about to Make a Picture* 1941–2
Pen and ink, watercolour
39.5 × 30.5
(15½ × 12)
Private Collection

In *Jehovah the Thunderer* (fig.53) a loosely organised set of wash, ink and pencil forms suggest the kneeling god of the title, hovering over a group of supine figures. A blue jet of energy explodes in a sword-like form towards the upper left. This is an angry god whose energy threatens all who are part of his creation. The artist, indeed, may be destroyed by the role he plays in living under this jealous and unpredictable power. *Creation Myth* (fig.54) proposes a more benign force. The foreground of a view of planetary bodies is dominated by a ball of compressed circular forms inside which is nestled a horizontal figure. This seems to be a further recapitulation of Lewis's theme of the heroic creator and suggests a human force seeking realisation within the dark potential of matter.

In *Lebensraum* II: *The Empty Tunic* (fig.55), Lewis fashions a grotesque helmeted head from a melding of severed human forms such as a foot, face and leg, flying like some deformed fury over a stormy landscape and encased in the German tunic which was devastating Europe – a destruction rather than creation myth. Lewis's art is at this stage haunted by demons which are both politically and personally tragic, whether rooted in his childhood or his difficult adult engagement with the horror of modern power.

Lewis's already strong theological interests became more pronounced during his stay in North America. His lectures to audiences of Basilian novices on 'Religious Expression in Contemporary Art' at Assumption College in Windsor, Ontario, in 1943, indicate how far his interest in contemporary Catholic thought had developed since the indefatigable converter of intellectuals Father Martin D'Arcy had, unsuccessfully, tried wooing him to Rome in the 1930s. He admired the Neo-Thomist theologian Jacques Maritain, whom he met at Assumption College in 1943, yet in his lecture on Georges Rouault, the French artist he described as 'the religious painter *par excellence* of our time', he advocated a highly unorthodox vision he was aware his audience would find challenging. Characterising Rouault as 'the painter of original sin', whose dark vision of masked brutality and deceit offers little hope of redemption in 'progress' or politics, Lewis in fact expressed hope for mankind in a new America-dominated world. Lewis quoted himself from *Time and Western Man* (1927) in siding with the Scholastic God of pre-existing 'Perfection' against the 'emergent TIME-GOD' of evolution, and saw in Rouault an extremist, medieval vision of depravity which rested on the Catholic God of 'achieved, co-existent supremacy'.[2]

Something of this position can be seen in the series of watercolours based on the Crucifixion which Lewis made in 1941. The rich line of *Small Crucifixion Series No.* III (fig.56) is indebted both to Rouault and to Chinese brush drawing, yet is unmistakably an invention of Lewis's alone. A human torso comprising seemingly botanical material sprouts new forms above a blood-red globe, reminiscent of some plates in Blake's prophetic books as well as of medieval imagery of the Cross as a living tree. Lewis's line and colour seem to have loosened, however, almost beyond recognition, as if the severity of his experience in exile had eventually shed an old self and given struggling, messy birth to a new being keen to find a new light.

53 *Jehovah the Thunderer* 1941
Pencil, ink and watercolour
37 × 25.5
(14½ × 10)
Private Collection

Below left
54 *Creation Myth*
1941
Pen and ink, pencil,
watercolour
37 × 25.5
(14½ × 10)
Private Collection

Below right
55 *Lebensraum II:
The Empty Tunic*
1941–2
Watercolour, chalks,
pen and ink
38 × 24 (15 × 9⅜)
Private Collection

56 *Small Crucifixion Series No.III* 1941
Pencil, pen and ink, watercolour
35.5 × 25.5 (14 × 10)
Private Collection

'Rotting Hill'

Lewis and his wife returned to London in August 1945. The final decade of Lewis's life was difficult but, as ever, both highly productive and controversial. His old Notting Hill flat was in a shambles, he was materially poor in a country living through the post-war years of austerity, and his illness and growing blindness made him irritable, frequently more paranoid than ever and subject to great physical discomfort. An often brilliant sequence of essays and stories in *Rotting Hill* (1951) paint a bleak and sardonic picture of the Britain he had returned to, while expressing hope for a new start. His career as a painter was effectively over, however, except for a few portraits and works on paper which reveal mainly his level of determination, and continuing dreams of 'isles of the blessed', in the face of growing adversity. It was as a critic and polemicist that his contribution to the art scene was most effectively expressed.

Lewis was the art critic for *The Listener* from 1946 to 1951 and supported the work of young British painters such as Francis Bacon, his own protégé Michael Ayrton, Robert Colquhoun, John Craxton, John Minton, Barbara Hepworth, William Scott and others. He espoused an eclectic aesthetic, still promoting what he now called an 'Earth Culture', yet looking for signs of an

internationalism within a distinctly British tradition. Throughout his career Lewis's critical writing is among the finest of any critic working in Britain in the twentieth century, not least because he created a powerful and striking language with which to convey his intuitive understanding of an artist's essential visual characteristics. Of Bacon, for instance, whom he described presciently in 1949 as 'one of the most powerful artists in Europe today', he wrote: 'Liquid whitish accents are delicately dropped upon the sable ground, like blobs of mucus – or else there is the cold white glitter of an eyeball, or of an eye distended with despairing insult behind a shouting mouth, distended also to hurl insults.' In Bacon's screaming figures he may have been seeing existentialist Tyros resurfacing after another world conflict.[3] Surprisingly, at least for those convinced Lewis was racist, he also vigorously supported the career of the young black artist Denis Williams, encouraging others to give him opportunities in exhibiting and teaching, and writing about his work which he admired both as aesthetic achievement and as the expression of the 'tragedy of the underdog'. In general, Lewis often used his space in *The Listener* to support adventurous young British artists who he hoped would find a more sympathetic response than he felt he and many of his contemporaries had received decades earlier. In the post-war world of official cultural optimism, Lewis proposed the new audience be diverted from blockbuster exhibitions towards private dealers and studios: 'The way for people to learn about pictures would be to go where they are painted ...'.[4]

While he had welcomed the Labour landslide victory in 1945, and since the 1930s had become a severe critic of British class divisions, Lewis was highly suspicious of the new state culture of 'Welfare Britain'. He described it as 'a big new racket' in which 'the optimism is not the confidence resulting from health, but rather the high spirits of the well-paid grave-diggers'. In *Rotting Hill* his story 'My Disciple' is a cruel satire on an actual visit to him made by an enthusiastic ex-soldier-turned-art-teacher who admired *The Caliph's Design*. Mr Gartsides, as he was called, was also an admirer of one of Lewis's *bêtes noires*, the art administrator, critic and theorist Herbert Read and, in Lewis's view, the promulgator of the idea that art education is about 'free expression' in which children were 'assisted' to 'be their little selves'. When Gartsides told Lewis how his class had worked with Plasticine and all made the same thing – a phallic lighthouse – Lewis responded: 'I see, of course. How amusing. Their personalities vanished momentarily. They became one – the primeval child.'[5] The 'Crowd' was back and, under a new 'Bailiff', making art. Lewis seems to have had a premonition of Antony Gormley's celebrated mass-participation work *Field* 1991. He was firmly opposed to art used to enforce a 'utilitarian moral' and although he greatly admired children's art, he was unconvinced by their latest mentors, the perpetrators of an aesthetic 'childermass'.

When the BBC commissioned him in the early 1950s to complete his trilogy of the afterlife begun in *The Childermass* in 1928, Lewis was able, in blindness, to visualise the epic world of radioactive power and corporate consumerism he would no longer be able to paint, in the remarkable final volumes of what he entitled *The Human Age*. Twenty years on, Lewis created in this last great effort a visionary world of stark political and technological

power, deeply compromised intellectuals and
bewildered and dependent masses; with an
acute eye for detail, Lewis shows the Bailiff
as now smart enough to live in a modernist
interior and to listen to Alban Berg. Pull-
man, now a composite of Joyce and Lewis
himself, encounters both a vacantly childish
angel in Third City (Heaven), and Sammael,
the devil, who dresses like Sargent's Lord
Ribblesdale and runs Hell like a modern
concentration camp complete with medical
experiments and horrific torture. Pullman,
naturally, becomes director of Sammael's
ideal university, which encourages the
immortal sphere to interbreed with humans.

Lewis's fantasy was a response to the
Cold War and by now he believed a further,
nuclear, world war was inevitable. He proposed in his book *America and Cosmic Man* (1948) that in its aftermath there should be a new federal world order based on American principles, accepting as he now did the need to adjust his views to the only human possibility in worldly affairs, the imperfections and compromise of liberal democratic political traditions.

57 Photograph of
the blind Wyndham
Lewis using a
dictaphone 1950s
Rare Books and
Manuscripts
Department, Cornell
University

Lewis's last intervention in contemporary art came after he had to cease writing art criticism in 1951 due to the onset of complete blindness, movingly described to his *Listener* readers in a final article, 'The Sea Mists of the Winter'. *The Demon of Progress in the Arts* (1954) was an attack on pure abstraction, on its drive to a 'nihilistic nothingness or zero' and on the established orthodoxy which he believed promoted it. Lewis had written about literary French Exis-tentialism in *The Writer and the Absolute* (1952) – once again showing how the immediate cultural landscape and its political and spiritual implications were his natural territory – and his essay on the visual arts continues this project in a different sphere. He saw in the abstraction of the *Réalités Nouvelles* exhibition in Paris the linked 'salvationist' ideologies of revolution and technology. Predicated on the value of 'newness', Lewis regarded the rising tendency as sustained by a new breed of 'middlemen' for whom perpetual innovation is a guarantee of their own political power. Lewis feared the impact such power-ful, infernal, forces could have on young artists, imagining, 'Mildly monu-mental, grandly sculpted, I perceive, aghast, some work of Moore's, as beautifully defined as a thundercloud, suddenly dissolving into an absurd abstraction, until at last there is nothing left of it but a phantom sausage, con-vulsed and withering into a white headless worm, a beginning of nothing.'[6]

A drawing of 1949, *What the Sea is Like at Night*, shows Lewis at the end of his career as a visual artist, seeking a way to invoke the onset of blindness and the fear of personal annihilation. Human, aquatic and ship forms twist and turn in a swirl of gouache and wash as conscious life struggles to find shape in the void. Lewis's nautical imagination hints at his fantasy of birth in a sea storm, the polemics of 'Blast', the idea of the 'artist older than the fish' and his

58 *What the Sea is like at Night* 1949
Pen, ink and gouache
56 × 37.5
(22 × 14¾)
Private Collection

fascination with Coleridge and Turner and the great Renaissance explorers. The man who, Canute-like, had stood firm against 'the flux' reveals his own immersion in the watery sublime elements of the mind and also suggests, perhaps, the losses he has suffered. In his unpublished final novel, 'Twentieth Century Palette', the artist hero attains the money, success and love which Lewis sacrificed to his own demanding principles and personal demons.

In 1950, recalling his first meeting with Lewis, the poet and critic Geoffrey Grigson wrote, 'In a London of selling, here was a man who was not for sale'. Wyndham Lewis died at Westminster Hospital in March 1957 fearing the worst, cursing the medical profession but, amazingly, solvent.

Notes

WLOA – Wyndham Lewis on Art: Collected Writings 1913–1956, ed. Walter Michel and C.J. Fox, London 1969

Chapter One: A Skeleton in the Cupboard

1 Wyndham Lewis, 'What It Feels Like To Be An Enemy', in the *Daily Herald*, 30 May 1932. In *WLOA*, p.267.

2 Wyndham Lewis, 'What It Feels Like To Be An Enemy', in the *Daily Herald*, 30 May 1932. In *WLOA*, p.266.

3 Wyndham Lewis, 'The Skeleton in the Cupboard Speaks', in *Wyndham Lewis the Artist: From 'Blast' to Burlington House*, 1939. In *WLOA*, p.336.

Chapter Two: 'Cryptic Immaturity' 1882–1908

1 Wyndham Lewis, letter to Thomas Sturge Moore, 12 July 1942, letter in Cornell University.

2 Osbert Sitwell, *Laughter in the Next Room*, London 1949, p.30.

3 Wyndham Lewis, *Rude Assignment*, London 1950. Reprint, ed. Toby Foshay, Santa Barbara 1984, p.249.

4 Quoted in Richard Cork, *Vorticism and Abstract Art in the First Machine Age*, London 1976, vol.I, p.3.

5 Wyndham Lewis, letter to his mother, undated, Cornell University Library.

6 Wyndham Lewis, *The Complete Wild Body*, ed. Bernard Lafourcade, Santa Barbara 1982, p.194.

7 Wyndham Lewis, *Rude Assignment*, London 1950. Reprint, ed. Toby Foshay, Santa Barbara 1984, p.126.

Chapter Three: 'Hob-goblin Tricks 1909–1912

1 Wyndham Lewis, 'The Meaning of the Wild Body', in *The Wild Body*, London 1927, p.243.

2 George Dangerfield, *The Strange Death of Liberal England*, London 1935.

3 Wyndham Lewis, letter to Thomas Sturge Moore, undated, University of London Library.

4 Roger Fry letter to Wyndham Lewis, 5 April 1913, in Denys Sutton (ed.), *The Letters of Roger Fry*, II, London 1972, p.367.

5 Lucien Pissarro, letter to Spencer Gore, undated, Ashmolean Museum, Oxford.

6 Wyndham Lewis, *The Complete Wild Body*, ed. Bernard Lafourcade, Santa Barbara 1982, p.216.

7 Wyndham Lewis, ibid, p.194–5.

8 Thomas Sturge Moore, *Art and Life*, London 1910, p.240.

9 Thomas Sturge Moore, letter to Wyndham Lewis, 6 October 1911, Cornell University Library.

Chapter Four: 'Complicated Images' 1912–1914

1 Wyndham Lewis, *Tarr*, London 1918. Reprint, ed. Paul O'Keeffe, Santa Barbara 1990, pp.58–9.

2 Wyndham Lewis, *The Complete Wild Body*, Santa Barbara 1982, p.195.

3 Wyndham Lewis, Interview with 'M.M.B.', *Daily News and Leader*, 7 April 1914. Quoted in Richard Cork, *Art Beyond the Gallery in Early Twentieth-Century England*, Yale 1985, p.184.

4 Wyndham Lewis, letter to Charles Handley-Read, 22 September 1949, in W.K. Rose (ed.), *The Letters of Wyndham Lewis*, Norfolk, Connecticut 1963, pp.504–5.

5 See Lisa Tickner, *Modern Life and Modern Subjects: British Art in the Early Twentieth Century*, Yale 2000, pp.78–94.

6 Wyndham Lewis, *Blast*, No.1. In *WLOA*, pp.44–6.

7 Wyndham Lewis, 'Enemy of the Stars', in *Blast*, No.1, 1914, p.65.

8 Wyndham Lewis, *Blast*, No.1, 1915, p.91.

Chapter Five: 'Monstrous Carnival' 1915–1919

1 Wyndham Lewis, letter to Ezra Pound, 22 June 1916.

2 Wyndham Lewis, 'The Crowd Master', in *Blast*, No.2, pp.94–102.

3 Wyndham Lewis, 'The Crowd Master', in *Blast*, No.2, p.94.

4 Letter to Ezra Pound, 14 June 1917, in Timothy Materer (ed.), *Pound/Lewis: The Letters of Ezra Pound and Wyndham Lewis*, New York 1985, p.75.

5 Wyndham Lewis, letter to Ezra Pound, 20 August 1917.

6 Wyndham Lewis, *Blasting and Bombardiering: An Autobiography*, London 1937. Revised edition, London 1982, p.195.

Chapter Six: 'What is This Place We Are In?' The 1920s

Chapter title: Wyndham Lewis, *The Childermass*, London 1928, p.68.

1 Wyndham Lewis, *Time and Western Man*, London 1927. Reprint, ed. Paul Edwards, Santa Barbara 1993, pp.376–7.

2 Wyndham Lewis, *The Caliph's Design: Architects! Where is Your Vortex?*, London 1919. Reprint, ed. Paul Edwards, Santa Barbara 1986, p.96.

3 Wyndham Lewis, 'Note on Tyros', in *Tyros and Portraits*, catalogue for exhibition at Leicester Galleries, London, April 1921. In *WLOA*, pp.188–90.

4 Wyndham Lewis, Interview in *Daily Express*, 11 April 1921.

5 Ibid.

6 Wyndham Lewis, 'Further Note' for 'Hoodopip', unpublished manuscript, 1920s, published in *Agenda – Wyndham Lewis Special Issue*, Autumn/Winter 1969–70, pp.185–6.

7 Virginia Woolf, letter to Sydney Waterlow, 3 May 1921.

8 Wyndham Lewis, 'Essay on the Objective of Plastic Art in Our Time', in *The Tyro*, No.2, 1922. In *WLOA*, pp.204–5.

9 Wyndham Lewis, ibid., *WLOA*, p.210.

10 Wyndham Lewis, 'Specimen Marginalia', Cornell University Library, published in *Wyndham Lewis Annual*, Vol.3, 1996, p.2.

11 Wyndham Lewis, Letter to T.S. Eliot, January 1925, in *Letters*, p.148.

12 Wyndham Lewis, *The Art of Being Ruled*, London 1926. Reprint, ed. Reed Way Dasenbrock, Santa Rosa 1989, p.321.

13 Ibid, p.93. Lewis's italics.

14 Wyndham Lewis, *Time and Western Man*, 1927. Reprint, ed. Paul Edwards, Santa Rosa, 1993, p.90.

15 Ibid, p.62.

16 Ibid, p.172.

17 Ibid, p.187.

18 Wyndham Lewis, letter to Olivia Shakespear, 1 June 1925, Cornell University Library.

19 Wyndham Lewis, *The Apes of God*, London 1930, p.383.

20 Wyndham Lewis, *The Caliph's Design: Architects! Where is Your Vortex?* London 1919, p.65.

21 Wyndham Lewis, 'The Politics of Artistic Expression', in *Artwork*, 1, No.4, May–August 1925, p.226.

22 Wyndham Lewis, 'A World Art and Tradition', in *Drawing and Design*, v, No.32, February 1929, pp.29–30. In *WLOA*, p.258.

23 Ibid., *WLOA*, p.259.

Chapter Seven: 'Lonely Old Volcano' The 1930s

1 Wyndham Lewis, 'Physics of the Not-Self', 1932, in Alan Munton (ed.), *Wyndham Lewis: Collected Poems and Plays*, Manchester 1979, p.200.

2 Wyndham Lewis, Foreword, *Catalogue of an Exhibition of Paintings and Drawings by Wyndham Lewis*, Leicester Galleries, London, December 1937, p.7. In *WLOA*, p.301.

3 Ibid.

4 Wyndham Lewis, *The Childermass*, London 1927. Reprint, Jupiter Books, London 1965, p.22.

5 *Catalogue of the Wyndham Lewis Exhibition* exh.cat., Leicester Galleries, Dec. 1937, p.7

6 Quoted as a caption in John Rothenstein, 'Great British Masters – 26: Wyndham Lewis', in *Picture Post*, 25 March 1939.

7 Wyndham Lewis, *Rude Assignment*, London 1950. Reprint, ed. Toby Foshay, Santa Barbara 1984, p.140.

8 Wyndham Lewis, unpublished typescript, 1930s, Cornell University.

9 Wyndham Lewis in *The Star*, 30 April 1938.

10 Winston Churchill, 'Toast to the Royal Academy', BBC National Programme, 30 April 1938.

11 Wyndham Lewis, quoted in *Time*, 30 May 1949, p.32.

12 Wyndham Lewis, 'Early London Environment', in 'T.S. Eliot: A Symposium', ed. Richard March and Tambimuttu, London 1948, p.29.

Chapter Eight: 'The Human Age' 1940–1957

1 Wyndham Lewis, *Self Condemned*, London 1954, p.259.

2 Wyndham Lewis, 'Religious Expression in Contemporary Art: Rouault and Original Sin', lecture given at Assumption College, Windsor, Canada, January 1943. In *WLOA*, pp.367–80.

3 Wyndham Lewis, 'Round the Galleries', in *The Listener*, 17 November 1949. In *WLOA*, pp.393–4.

4 Wyndham Lewis, unpublished typescript, 1950s, Cornell University.

5 Wyndham Lewis, 'My Disciple', in *Rotting Hill*, London 1951. Reprint, ed. Paul Edwards, Santa Barbara 1986, pp.227–40.

6 Wyndham Lewis, *The Demon of Progress in the Arts*, London 1954, p.6.

7 Geoffrey Grigson, *The Crest on the Silver: An Autobiography*, London 1950, p.165.

Photographic Credits

Unless otherwise stated, copyright in the photograph is as given in the figure caption to each illustration. Julia Atkinson 53, 56; Courtesy Austin/Desmond Fine Art Ltd 58; Ben Blackwell 16; Bridgeman Art Library/Ferens Art Gallery 27; Bridgeman Art Library/ Imperial War Museum 22; Bridgeman Art Library/Leeds Museums and Galleries 28; Bridgeman Art Library/ Southampton City Art Gallery 11; Bridgeman Art Library/ Yale Center for British Art. Photograph by R.Caspole 8; Courtesy Anthony d'Offay 3, 30–31; Tate Photography/ Dave Lambert 5, 32, 35; Robert Wedemeyer 34, 42

Copyright Credits

Chronology, with a list of Lewis's major publications

1882 18 November. Born in Nova Scotia.

1888–99 At school in England.

1899–1901 Slade School of Art – prize draughtsman.

1902–8 Travel in Europe.

1909 First short stories published. Member of Camden Town Group.

1911–12 First Cubist- and Futurist-inspired works.

1913 *Timon of Athens* portfolio. Dispute with Roger Fry. Founds Rebel Art Centre.

1914–15 Leader of Vorticist movement and editor of *Blast* – two issues.

1916–19 Artillery officer and official war artist.
The one-act drama 'Ideal Giant', the short story 'Cantleman's Spring Mate' and other pieces published in *Little Review*.

1918 *Tarr*, a novel, published.

1919 *Guns* exhibition, Goupil Gallery, London.
Fifteen Drawings portfolio published.
The Caliph's Design published.

1920 'Group X' exhibition, Mansard Gallery, London.
Mother dies of pneumonia.

1921 *Tyros and Portraits* exhibition, Leicester Galleries, London.

1921–2 Edits *The Tyro* magazine – two issues.

1926 *The Art of Being Ruled*, a book of political theory, published.

1927 *Time and Western Man*, a book of philosophical and literary criticism, *The Lion and the Fox*, on Shakespeare, and *The Wild Body* short stories published.

1927–9 Edits *The Enemy* magazine – three issues.

1928 *The Childermass* (Part I), a metaphysical novel, published.

1929 *Paleface*, a book on race, published.

1930 *The Apes of God*, a satirical novel, published.
Marries Gladys Anne Hoskins.
Travels to Germany.

1931 *Hitler*, a book of political journalism, and *The Diabolical Principle and the Dithyrambic Spectator*, a book of art theory, published.

1932–4 Serious illness.

1932 *Snooty Baronet*, a satirical novel, *Doom of Youth*, a book of cultural theory (suppressed), and the North African travel book *Filibusters in Barbary* published.
Thirty Personalities and a Self Portrait, drawings portfolio, published.

1933 *The Old Gang and the New Gang*, on politics, and *One Way Song*, poem, published.

1934 *Men Without Art*, a book of literary and aesthetic criticism, published.

1936 *Left Wings Over Europe*, a political polemic, and *The Roaring Queen*, a satirical novel (suppressed), published.

1937 *Count Your Dead: They are Alive!*, a political polemic, *The Revenge For Love*, a novel, and the autobiographical *Blasting and Bombardiering* published.
Major exhibition at Leicester Galleries, London.

1938 RA rejects his portrait of T.S. Eliot.
The Mysterious Mr Bull, about the English, published.

1939 *Wyndham Lewis the Artist: From 'Blast' to Burlington House*, an anthology of art writings, *The Jews: Are They Human?*, a defence of the Jews, and *The Hitler Cult*, an anti-Nazi book, published.
Leaves London for Canada/USA.

1940 *America, I Presume*, a book about Lewis's first impressions of the USA, published.

1941 *Anglosaxony*, on political theory, and the novel *The Vulgar Streak* published.

1942–5 War artist, lecturer at Canadian Catholic seminary. Living in Toronto and Windsor, Ontario.

1945 Returns to Britain.

1946 Art critic for *The Listener*.

1948 *America and Cosmic Man*, a book of political theory, published.

1949 Exhibition at Redfern Gallery, London.

1950 *Rude Assignment*, an autobiography, published.

1951 Loses sight.
Rotting Hill, a book of essays and short stories, published.
The Childermass dramatised on BBC radio.

1952 *The Writer and the Absolute*, a book of literary and philosophical criticism, published.

1954 *Self Condemned*, a novel, and *The Demon of Progress in the Arts* published.

1955 *Monstre Gai* and *Malign Fiesta*, sequels to *The Childermass*, published and dramatised on BBC radio.

1956 *Wyndham Lewis and Vorticism*, Tate Gallery exhibition.
The Red Priest, a novel, published.

1957 7 March. Dies at Westminster Hospital, London.

Bibliography/Further Reading

A list of Lewis's major publications is included in the Chronology. The following works are the best sources for studying Lewis and for information about further reading.

The fullest bibliography of Lewis's work and writings on him is Bradford Morrow and Bernard Lafourcade, *A Bibliography of the Writings of Wyndham Lewis*, Black Sparrow Press, Santa Barbara 1978.

The fullest catalogue of Lewis's paintings and drawings is Walter Michel, *Wyndham Lewis: Paintings and Drawings*, Thames and Hudson, London 1971.

An anthology of Lewis's writings on art is Walter Michel and C.J. Fox (eds.), *Wyndham Lewis on Art: Collected Writings 1913–1956*, Thames and Hudson, London 1969 (*WLOA*).

A useful selection of Lewis's correspondence is available in W.K. Rose (ed.), *The Letters of Wyndham Lewis*, Norfolk, Connecticut 1963.

The most recent major exhibition devoted to Lewis's art was *Wyndham Lewis: Art and War* at the Imperial War Museum, 1992, with a catalogue by Paul Edwards published by Lund Humphries, London.

The outstanding scholarly study of Lewis as writer and artist is Paul Edwards, *Wyndham Lewis: Painter and Writer*, Yale 2000. This also includes a long bibliography of writings on Lewis.

The most recent biography of Lewis is Paul O'Keeffe, *Some Sort of Genius: A Life of Wyndham Lewis*, Jonathan Cape, London 2000.

Index